XY FILES:

POEMS ON THE MALE EXPERIENCE

XY

FILES

POEMS ON THE
MALE EXPERIENCE

EDITED BY
JUDITH RAFAELA & NANCY FAY

SHERMAN
SA ASHER
Publishing

Poetic License
This is a work of imagination. Any use of similes or metaphors relating to actual people living or dead is art. It contains truths not supported by facts.

Acknowledgments appear in the contributors section

Cover and section design by Janice St. Marie
Book Design by Judith Rafalea
Photography Credits:
Cathy Maier Callanan, "wedding day", p. 33
Jenny Goldberg, "lunch break in the city", p.73
Jennifer Esperanza, "of the earth", p.101
Rebecca Sherman, "Carl Marley and Mike", p.133
Family archives, "Frank Buff", p.183

ISBN 0-9644196-6-1
FIRST EDITION

Library of Congress Cataloging-in-Publication Data
XY Files ; poems on the male experience / edited by Judith Rafaela &
 Nancy Fay. -- 1st ed.
 p. cm.
 Includes index.
 ISBN 0-9644196-6-1 (trade paper ; alk. paper)
 1. American poetry--Men authors. 2. Masculinity (Psychology) -
-Poetry. 3. Men--Poetry. I. Rafaela, Judith. II. Fay, Nancy.
PS590.X9 1997
811' .540809286--dc21 97-15225
 CIP

Sherman Asher Publishing
PO Box 2853
Santa Fe, NM 87504

EDITORS NOTE

How can women edit a book about men?

In our first anthology, *Written With a Spoon, A Poet's Cookbook,* we combined our dual passions for food and poetry. In *XY Files: Poems on the Male Experience,* we turn the spotlight of poetic truth on the subject of men— a subject for which we have passion, confusion, contempt, longing and, finally, love. We asked writers to wrestle with the complexity of the male condition. The responses presented here are from over one hundred contributors: young and old; male and female; straight, gay, and adopted personas; ethnically diverse; and reflecting many poetic styles.

This poetic documentary celebrates the lives of men yet attempts to look at pain, pathology, and problems without being mean spirited. The book is organized into files representing facets of the male experience. Each file opens with a haiku, haiku-like, or short poem to cause that quick "ah haa" intake of breath, an opening or closing of a window of insight.

"Where do we file this?" was our working question as we tried to match poems to categories under construction. We often wished for hyptertext to show the overlap of subjects as we modified the file names and content lists, especially "Longing.Silence.Can't Say"— an elusive concept. Women know what we mean by this section but no man was able to give us a concise phrase to describe it. Judith's husband had the best answer, "I know, but I won't tell you."

We could not have completed this anthology without help from our wide web of friends and family. We want to thank Stella Reed for reading and organizing the stacks of submissions and insisting on chocolate, Barbara Katz for transcribing all the poems and her tireless support, Richard Lehnert and Julia Deisler for meticulous copy-editing. Any errors left are ours. Finally we thank all our contributors who were extraordinarily patient while we were in the hunting and gathering phase and quick to respond when we announced deadlines.

This book is dedicated to the men in our lives who have challenged us, cherished us, argued with us, infuriated us, and been our allies. We believe that poetry empowers us to decrease gender isolation, dismantle the patriarchal structures that damage us, and increase understanding to build toward a peace that serves us all.

<div align="right">

Judith Rafaela & Nancy Fay
Santa Fe, NM 1997

</div>

CONTENTS

TASTING FIRE

SEX.LOVE.OH BABY

Longing.Silence.Can't Say

Working

AL FRESCO

BODY PARTS

FATHERS & SONS

MYTHS

ELEGIES

"Anything dangerous to do around here?"

-Hunter in Iron John,
Robert Bly

TASTING FIRE

> tangled kites abandoned
> match box — empty
> the boys can't stop laughing
> —Nancy Fay

TASTING FIRE

My brother Matt tried to taste fire
when he was five. He climbed on top
of the redwood picnic table next to the grill.
Sundays during the summer, Dad cooked
outside, this time turning fat
polish sausages over the hot rusty bars.
Red and slippery, the meat looked like our beagle
when he got near a dog in heat.
Each time a sausage dripped juice, more flame
flew from the black pit like children
playing peek-a-boo. Dad thought that Matt wanted
closeness to him, but I saw in his eyes
hunger for those flames, the same look
Dad gets watching cheerleaders.
Matt perched on all fours,
butt higher like a cat about to pounce,
eyes fixed on the teasing flames.

THE BOYS HAVE GUNS

There must be eight of them,
no, ten, all with flashy wind-
breakers, brush-cuts, scuffed
sneakers, the clean, licked
look of animals. Someone has been
mothering them, sailing them out
into this March wind to play.

The lawns they cross so casually
—clefts through enemy turf.
They speak with the cold glint
of metal, rush headlong, aimed.
Death music shoots from them.

What is it these boys hold close
to their own precious bodies?
Can it be the dark winter night
or a slain bird, still warm
and throbbing? Something soldierly
curls from their fingers like smoke.

IN THIS POEM I AM TEN YEARS OLD

My name is Vinnie or Tommy or Wade
and I've been driven by my grandmother
to this town "in the sticks" to visit
Aunt Connie who has a thick waist
and a thin strip of hair above her mauve
lips and nervous hands that are quick
to brush over my face.

I've taken a walk near the tracks:
the black weeds between the rails grow
right out of the gravel, blue sky
cascades down to my shoulders, something
is ticking in my head like a big gold
watch, I know I could pluck the sun
just by reaching my fingers.

When the train comes, blowing heat
and distance, I let go, I open
up. Hundreds of boxcars quake and thunder
through me.

EMMETT'S DECISION

after a photograph by Sally Mann

The last time Emmett modeled nude he was nine years old. It was at the lake, late one afternoon. As he emerged from the water, still waist deep, his dark hair pasted against his forehead, his ribbed chest glistening, I asked him to please let me photograph him. He stood glaring at me. I asked him to come forward just a step or two and let his outspread hands hover over the glassy surface. His waist tapered to the groin where his small penis floated under a few inches of liquid light. He said this would be the last time, that he was too old to be photographed naked. If this was to be the last time, I said, could I have a smile? He refused. Take the picture, he said, so I can go back. Go back where? I asked. Back there, he said, pointing to that part of the lake in deep shadow where a stand of trees grew at the edge, their roots emerging twisted and gnarled in the lower bank. I had seen him there often, sitting and leaning back on one root that extended like an arm. What's so important over there? Besides, it'll be dark soon, I said, focusing the camera. As soon as I pressed the shutter release Emmett smiled and asked what we were having for dinner. You rascal, I said. Let me take just one more. No, he said, and then he turned and swam away, his thin body suddenly a presence of power in the lake.

SINCE DANIEL

for Peter, E.J., Ryan, Sarah, Hal, Brandon, and Chris

Since Daniel jumped
From the towering cliffs
Above the light shimmered lake
And caught the wind to his death
And fish puckered their mouths
Against his quivering body,

Since Daniel . . .
Peter cries
Harder than I've ever seen him,
And I am clumsy matter
Revolving around small guilty acts
Such as flossing my teeth
And mopping the floor.

Since the container of Daniel's body
Spilled its soul into the lake
There have been dreams
Of floating infants
On the wrong side
Of high metal fences.

His teachers dream
Their dogs are dying.
His sister, unknowing,
In a remote Mexican village
Dreams his death,
And his friends linger
To kiss their mothers
Goodbye in the morning.

Since Daniel jumped,
Icarus embracing the air
With four limbs
And a winged love of sailing,
Since Daniel,
I saw an injured bird in the schoolyard fly.
The trees bow their heads
And the parched sky grows tall clouds,
Gray cliffs against reverse water—
Above, the joyous, Lake
Below, the receptive, Earth.
The I Ching says:
"Gathering Together:
Regret not. Going is without blame."

TESTOSTERONE

just barely still a child
I sit in the family room asking
pesky questions while
a TV repairman named Bacon
and his gap-toothed apprentice
tinker with the fickle
Motorola something's haywire
in the tuner but they keep
to their work and suddenly
the screen clears up
and Mickey Mouse Club comes on

the apprentice stares
at Annette says to Bacon
girl's got a
body'd make a
bishop kick out a
stained-glass window

yeah says Bacon but I think
she's 'bout a bubble off
plumb or else too young

gaping speechless then

who cares says the apprentice
as they leave thus the onset
of my long puberty

RED LIGHTS

Red light district, 1966
Amsterdam Streets: women
in windows calling their harsh
Dutch syllables, gesturing
the way fish do when we haul
them in, weighting down the swashed
deck with their dazzling bodies.
Red lights in Genoa that same
summer: beers bought by a docked
shipload of sailors who delivered me
to a back-alley door—my first real woman,
they swore. And she, who knew me
intimately and wore my body, never knew
my name, and what passed for
"intercourse," I think, lasted no more
than a star blink: *Ciao, bambino*!
as I slid out her door into the cold
and burning night. Red lights
of midtown New York, stark cluster
of rooms with a bulb blaring above
a sagging, rumpled bed, blonde-wigged
black woman I came to for "aid
and comfort," for answers to questions
my body couldn't ask: Was I a man
or a lost child grown up? would I crash
in the dark surf, or could I ride the wave
of my blood all the way to life?

To Be a Boy

There is no good way to be a boy.
You will break everything.
Anything your sisters have
That you touch will break.
It will always be your fault,
You should know better.
You will have your own room,
Your own toys, your own clothes;
And your sisters will hate you
For that. You will think
You should be like your father;
And here is the part
That makes no sense—
To do that, you will have to
Get your mother to hate you.
You will set ants on fire
With a magnifying glass.
You will never tell anyone
Because you will feel guilty.
You will set the backporch on fire
With the same magnifying glass;
This will be an accident.
The ants were on purpose.
At times you will be like your father,
And your mother will hate you.
You will wear out your shoes too fast.
You will wear out your mother's patience, too.
There is no good way to be a boy.
When you realize that,
You will be a man.

HAIR-PULLING FIGHT

When my brother Willis was eleven he
Got into it with another kid at
Eastview School and it wound up
In a little set-to of fisticuffs

A kid named Manfred grabbed a handful of
Willis's hair over his right forehead
And pulled so hard it left a bare spot
In a spot that could not be covered up

Mama saw the bloody skull and got
The rundown from Willis
Mama said Why that kid is fightin' like a girl
Pullin' hair!

Mama told Willis if he couldn't whip
That kid that she sure could

Willis would have been too embarrassed to
Have his mother fighting his battles for him
And the next time he got into it with
Manfred, Manfred got "whupped"

Mama put some Vaseline on Willis's bald spot
And after a while the hair grew in again

History Lesson

The bullies grabbed me
outside my history class,
and though I struggled wildly
they stripped me and bundled me

into a cupboard under the stairway
that reeked of dust and chemicals
and spider dark. My world was framed
by light around the door.

I didn't shout or cry.
I'd learnt that I had to obey
forces bigger than me:
my first naked encounter with history.

GARY'S WAY

I was a gay teenager
but didn't commit suicide

though I tried.
My folks pulled me back

from the brink,
sent me to church camp,

a youth group, scouts, a shrink.
They put everything in gear

to keep me from "turning
queer,"

but I never turned, just was,
and now I'm learning

how to make mistakes
and how to love because

joy slipped the noose of despair.
Even when grief aches,

a razor on my backbone,
I remember others share

my pain—and my anger. So I
no longer feel in danger, alone.

A Short History of Sex

"Hijo, this is the lightswitch. No pay you bill, no light, and you make babies with no light." This was Grandmother telling me about sex, or hinting about how sex works. If you don't pay up to the PG&E, then all you have to do at night is lay in bed and make love. This was my first introduction to cause and effect, how one thing leads to another. I was eleven, eating a peach from her tree and watching her water the lawn that was so green it was turning blue. Grandma turned the hose on me, said, "Now you play," and squirted me as I ran around the yard with my jaw gripping the peach and my hands covering my eyes.

It was different with my mother, who broke the news about sex while folding clothes in the garage. "You get a girl pregnant, and I'll kill you." No logic there, just a plain simple Soto threat. I felt embarrassed because we had never talked about sex in the family. I didn't know what to do except to stare at the wall and a calendar that was three years old. I left the garage, got on my bike and did wheelies up and down the street, and tried my best to get run over because earlier in the week Sue Zimm and I did things in Mrs. Hancock's shed. It was better, I thought, that I should die on my own than by my mother's hand.

But nothing happened. Sue only got fat from eating and I got skinny from worrying about the Russians invading the United States. I thought very little about girls. I played baseball, looked for work with a rake and poor-boy's grin, and read books about Roman and Greek gods. During the summer when I was thirteen I joined the YMCA, which was a mistake, I thought—grown men swam nude and stood around with hands on their hips. It was an abominable exhibition, and I would have asked for my money back but was too shy to approach the person at the desk. Instead, I gave up swimming and jumped on the trampoline, played basketball by myself, and joined the "combatives" team, which was really six or seven guys who got together at noon to beat up one another. I was gypped there too. I could have got beaten up for free on my street; instead, I rode my bike three miles to let other people I didn't even know do it to me.

But sex kept coming back in little hints. I saw my mother's bra on the bedpost. I heard watery sounds come from the bathroom, and it wasn't water draining from the tub. At lunch time at school I heard someone say, "it feels like the inside of your mouth." What feels like that? I wanted to ask, but instead ate my sandwich, drank my milk, kicked the soccer ball against the backstop, and then went to history, where I studied maps, noting that Russia was really closer than anyone ever suspected. It was there, just next to Alaska, and if we weren't careful they could cross over to America. It would be easy for them to disguise themselves as Eskimos and no one know the difference, right?

In high school I didn't date. I wrestled for the school, the Roosevelt Rough Riders, which was just young guys humping one another on mats. I read books, ate the same lunch a hundred times, and watched Mrs. Tuttle's inner thighs and thought, "It's like the inside of your mouth." I watched her mouth; her back teeth were blue with shadows, and her tongue was like any other tongue, sort of pink. I wanted a girl very badly and went around with my shirttail pulled out, and once almost had a girlfriend except she moved away, leaving me to walk around eating a Spam sandwich.

My mother's bra on the bedpost, my sister now with breasts that I could almost see behind her flannel nightgown. One night my brother bragged that he knew for sure it felt like a mouth and in fact was drippy like half-chewed peaches. In the dark I scrunched up my face as I imagined baby peaches falling from a dark hole.

I had to have a girl. I was desperate. I stuffed Kleenex in my pants pocket and went around with no shirt. I thought of Sue Zimm. But she was now lifting weights and looking more like a guy than a girl, which confused me even more, especially when George from George's Barber rubbed my neck and asked me how it felt. I told him it felt OK. He asked if I was going steady, and I told him that I sort of was, except my girl had moved away. He said that it was better that way because sometimes they carried disease you couldn't see for a long time until it was too late. This

scared me. I recalled touching Sue when I was thirteen and wasn't it true that she coughed a lot. Maybe something rubbed off onto me. I bit a fingernail, and walked home very slowly. Years passed without my ever touching a girl.

I was twenty, the only guy who went around eating Spam sandwiches in college, when I had my first girlfriend who didn't move away. I was a virgin with the girl whom I would marry. In bed I entered her with a sigh, rejoiced "Holy, holy" to my guardian angel, and entered her again. I couldn't believe what it looked like. While my girl slept I lowered myself on an elbow and studied this peach mouth, squeeze thing, little hill with no Christian flag. Pussy was what they called it: a cat that meowed and carried on when you played with it very lightly.

Michael L. Johnson

. .

MY SON'S PUBERTY

Child infinite in faculty no more,
he's let his head become a basketball.
The phone rings, rings, rings, and his voice grows low.
His room grows posters—black men, very tall.
He sleeps late. His heart is a free-for-all.
I want to tell him this gets worse before
it gets better, but what do fathers know?

PREEN

Watchful birds of prey
Andrew and I
Sharpened our talons and our eyes because we were begin-
 ning to see that
Preadolescence is like a slab of granite in which you are born
 and from which you must claw your way out
As it happened every weekday
When we sat on the steps
Outside a school of ballet
Like two young boulders
Half obstructing the path
Of the dancers
Stepping over us
Leaping and flying slender herons over us
Always ten minutes late
With their legs rushing past
A million trees made of almond or dressed in stocking
They would clatter up the four cement steps
This was the sound of dry chalk snapping
Followed by rings on their fingers skating across the handle
 of the door
And as one more ballerina was inhaled by the building
Sometimes a smile like a sliver of ivory moon
Gracefully fell into the palm of my hand
So I shoved my fists deep in my pockets
Considering my victory
Did you see that one? My friend would ask me
As though we were looking for shooting stars
And indeed
Even the sky had become a woman
Combing her tresses the lavender clouds of early evening

WE ARE MORE BOYS THAN MEN

Wrestling on the sofa,
black and white t.v.
too loud,
empty ice cream bowls
on hardwood floor.

We are "porn pigs"
talk in our cruellest voices
—truck driver with
mean mouth,
prison guard with night stick.

And when it's over,
you go outside. Settle into
a book.
It's dark,
you've brought a candle.

Me, I sit here
at my warm typewriter
pretend to be Jean Genet,
pull, finger,
torment my filthy hair.

Push Ups

Sergeant Smith: Mosley's going to set the brigade record. He only needs 230!

That night down on the floor
while we counted, your arms,
so fluid, pumped, stretched,
dropped your body an inch above
the tile, then lifted you so high
that something had to give—
the floor, the tiles—something
had to break. No sweat, just
repetitions, "100," "200," "229!"

and then you stopped. I knew
why once, the time, the atmosphere,
the need to articulate something
that could not be grunted out
to prove something to yourself
and all of us. Goddamn but you
were cool when you held yourself so still,
looked up at all of us and laughed.

You lifted one hand from the floor, brushed
a drop of sweat from your lip, stood up
and walked away.

DAREDEVIL

Hard helmets and high boots
tumescent in the sun,
got-up in rubber skin
and leather hide,
black, strapped, laced,
buckled with grommets,
chrome and brassy-eyed,
their dress itself is an act of sex,
as the body, used,
tumbles to its end
like jointed dolls we outgrew
and threw aside.
So the exalted race
to their base death
in self-abuse begins,
as the body's transient existence
sings its violent end,
to replace that dull, dull death
that waits upon the rest of us
behind a desk,
behind another desk,
behind the coffin lid
closing like an office door.

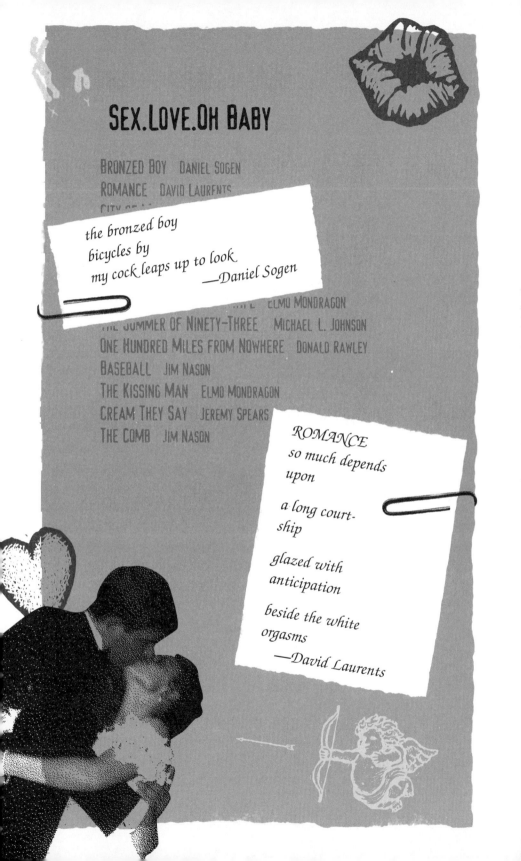

SEX.LOVE.OH BABY

the bronzed boy
bicycles by
my cock leaps up to look
—Daniel Sogen

ROMANCE
so much depends
upon

a long court-
ship

glazed with
anticipation

beside the white
orgasms
—David Laurents

CITY OF MEN

I am in love in a city of men.

Men who grab
my backward glance
with the threatened beat
of their breath,
men whose nights
are convenient and sly.
Men with mirrored glasses and rifles
laughing on the freeway,
men who punch the air with
their angry sex,
men with the squint of a hyena.

This is my city
and I smoke cigarettes like convicts.

My men are as peerless as dukes
with the static strength of statues,
with their cocks in hand
tempting fate
and the hair on their bellies a warning.
My men are prudent with joy,
men who discard love and memory
when their sight
has big muscle and hair.
Men who allow me crime and melancholy.
Men who allow me nothing.
I take it all like barbiturates
and I am in a sleep of men.
Men who disorient me.

They take my eyes like dice.
I study their buttocks with
the greed of a child.

Men. I can be a vanishing act.

Men who know how to smoke a cigarette
without women's fingers,

men who understand their role.
Men with caked hair
under their arms,
men with pink skin and a lisp,
beautiful men with histories and gifts
as constant as a fine bell.
Men who die for no reason.
Men who have a white light,
like Valentino or Clara Bow,
the light moths
kill themselves for,
the white light that makes me
sit up and blink like a child,
a pupil
a student of men's eyes
lit with candles and starch,
a congregation of men
who are fireflies and saints.

Men who are as kind as
any animal who can steal.
As kind as your sexual history of Mexico
with your men reeling with tequila.
Men who smell fine as dirt
and the salty perfume of paid sex,

men who allow their semen
to run through every channel.

Men. I can touch their palms when I dream.

Young men with still perfect limbs,
ex-husbands in loud sweaters,
groomed men with clenched teeth
who hover in packs beyond the shotgun eyes
of deserted women,
fat men with a comic's sweat and ripe hands,
tired men sitting on safe settees
full of bibles and loss
beyond the dull swipe
of rolled lawns,
men who make love with piety
canonized in a frenzy of flesh,
men who masturbate their lives
so that even daylight
becomes their own private keyhole.

Men with cars for girlfriends,
men who live in air-conditioned ruins
choking with ghosts and fearing rain,
men who slam doors and telephones,
men who have secrets and money
and clean nails,
black men with skin
like wet grapes
and teeth like winter clouds,
drunk men who walk like dancing bears,
old men with wrinkled, ruined cocks
that peek out like rummy sailors,
men whose skin accumulates layers
like a granite shelf,

men with twisted veins like
Monterey pines running down
their clenched arms and spread legs.

Men whose lust is hurried and benign,
men whose lips are a crime,
men who are boys that play
with black leather and Vaseline,
boys who shadow box their
fancy passions in alleys
and steam rooms until dawn.
Men who ride horses naked in the desert.
Men who surrender nothing.

Men with the pinched faces of thin air,
staring out of glass buildings
so high they can only see mountains
they do not understand.
Men in average blue suits
with wives in another state,
men with the laughter of poets
running elevators and pumping gas
with delicious, cracked large dry lips,
smoking unfiltered Pall Malls
and scratching their asses.

These are the men with the rhythm of
my city's white light,
men whose eyes are lit by gin and possibilities,
men who work in airports
and have never flown,
men who are not safe in numbers,
men who drive beat-up cars
and live with scarred women,
men who watch the stars
with drugs and candles from the roofs of shabby buildings,
men who come like a car wreck,

men who are mindless
with prodigy,
men who eat rocks,
men with cypress green eyes
and hairy shoulders,
men who devour
a callous embrace,
all the men I find
beyond my barricades,
all men that tell me
of hymns of earth
and the strength of my loins,
of tasting the white light,
of being in love in a city of men.

Tim Myers

LOVERS

A man who loves a woman
is like clouds and clouds and clouds
streaming over a fertile valley
on winds from the unstill sea.
He looks endlessly on her
in soundless entrancement,
clouds and clouds and clouds until
the ache within him grows
to tingling, he is almost
distraught with the dark weight
of his adoration;
then gathers;
rains.

THE WASHING OF THE FEET

We will grow a time, in time,
when we lie late in oil-light,
skins ambered by wick and dark
as every star that trembles
in cold and fear and joy
shakes down its splintered light.

Wary of our mixed desires,
I'll ask your knees to bend
around the world's soft edge,
to let your feet fall in the dark
beneath the floating bed,
and you will sit there, or not,
trusting me or wanting to.

If you do I'll wash your feet
in fragile water poured
from a jar of clay
to a bowl of clay,
earth taught to hold water by air and fire,
water held tall poured to
water let low, round, open,
between containing sexes
the falling shapes of infinite air.

And as the smell of rain-blacked earth
lifts to light at the top of the room,
and as you smile or laugh
in fear or wondering shame,
or lean your long hair down
and in that darkened tent
press your tickled lips
in one dry kiss upon my hair,
or cry at such strange release
from living's long ache,
you'll watch my bent head

and feel these slow, wet hands
and hear the water part around your feet
to fall back, bright and broken,
in shards that glitter in the ear.

In the water is earth
and why it is dark in the dark;
all my sloughed-off skin,
paring of fingers and toes,
callus flakes and scabs,
the crust of semen on my belly as I wake,
and from my sun-cracked eyes
night-sand tracked in
on the soles of dreams.

With all the hair my life has grown
and cut and grown again
I'll wash your feet.
With the ashes of my dead
I'll fill the maps of lines
that craze your soles,
and scour them with broken teeth
and bits of bone.

I'll bless your tired feet,
last of you to leave the womb,
feet that carried you first
from mother's arms to father's,
feet that cupped the earth's warm head,
which turned and rose to them,
and in a life of walking
brought you here—
to break the waters in my hands
and trust me into knowing
where you stand.

As It Was in the Beginning

She was underneath me. I had my hands on her face.
Sunday morning, in a house, in a house surrounded by water.
I stroked that rich color you don't find every day.
Her hair, red and wild, more red, more wild
against the white sheet. The whole place white
but not cold, green hill out the window,
the water gray on its way to silver. We moved
ever so slightly. The house on its moorings creaked.
A little music from her throat, or was it coming
from the bay? We were any two creatures floating.
Wetness everywhere, the whole world liquescent, delicious.
In a white room without time, we were tensed together
without need of time, my hands, my long hands on her face,
the heat there so familiar. Is this prayer, I wanted to know.
And she said, Yes it is. Make it last forever.

THE SHEEPHERDER TO HIS WIFE

I want the earth in my speech
When I try to say your weight in my life.
The skies should darken.
Only the thin vivid blue of the horizon
Should remain. The colors of the rainbow
Will not satisfy, nor the sunset
Nor the sunrise. Not the moon,
Not even the infinite stars
Lonely in the mountains. Or they will.
If the cold night carries the cries of wolves.

Sometimes a grief overwhelms me
And I mourn my own life.
I see myself tired and beyond my strength, still going on.
I want to be in the highest mountains
Nearest the presence of God, crying until the rain comes.
Then I think of your life, and my heart kicks in my chest.
Moist, dark storm ready to burst.

Enough! I say enough to all that would harm us.
Let the worms beneath our feet seek other sustenance.
Let the wolves shriek in a more bitter wind than ours.
Soon the first snows will gently drift down the sides of our mountains.
Soon those tender flakes will be
the fountains of our sleep

THE SUMMER OF NINETY-THREE

Today the air conditioner broke down.

It's summer solstice and the hottest day
so far this year.
 An old girlfriend (same voice
but weaker) called to say she was divorced,
now living alone in the very house
I grew up in—and how weird she had felt
sleeping there the first night, lying on top
of the covers, thinking back.
 I thought back
to nights in the heat wave of fifty-five,
when I lay without sheets and without air
conditioning, just fans—nights hotter still
from dreams of her—wondering what the fires
of hell were like.
 Tonight I want to love
my young wife, her breasts almost miracles
in the firefly-lit and sweltering dark.

Hell is not temperature. Hell is time.

One Hundred Miles from Nowhere

Joe Turner is singing "Honey Hush"
on the radio, in the front seat
of a purple Chrysler.

We are a hundred miles
from nowhere and snow
is falling on Nevada Mountains

with Indian names of eagles,
dead chiefs and cacti.
Our windows are steaming.

You discard your shirt,
rub your nipples, light a cigarette.
You are full of wile and rumor.

Your cock flaps on your stomach.
Peppermints fall off the dash.
You pull my head down, close your eyes.

Johnny Tillotson is singing
"The Pillow You Sleep On,"
and a crow lands on the roof.

He taps the car metal,
like a piano clock,
like a frightened child's knock.

He hops on the roof
like a woman's nails at a bar
waiting for the eighty proof.

It's death, you say, at the door,
and you wrap yourself around me.
Your hip is soft against my ear.

Your groin shivers, your lips drop.
Spent and infuriated,
you thrust in staccato.

It's only a crow, I say.
And he's gone, flying into the flurries
with strong black wings.

I hear "Daddy Cool" by the Rays,
and the road is thick as paste.
We are blind with snow and steam.

Do you know where we are? you ask.
I know where we've been, I say,
and you stroke my chin in silence.

BASEBALL

Curled up fetal,
your back hard
against me.
I try not to breathe.
What if you wake,
catch me again mooning,
craving your curve, line,
love's discontented hardening.

Love is grief
I tell you.
It is a limp
in your throat,
an air grasp
in your breathing,
a sadness gap
slick and black
as night's curtain tightening.

Love, of course, is also
about fields, diamonds and bases.
About summer sun and ants
pulling crumbs
bigger than
their black-bubble-back-sectional selves
across sand too hot
for barefoot walking.
Each stilt-walks, drops,
carries on with life's
pull, crawl and yawning.

My hand between thigh
and cheek: soft and hard,

love's dirty dampness
welcomes me.
I move closer, squeeze-kiss
your shoulder,
smell the sunburn stain
of the game
in your skin.
A day of chase and run.
Of man-talking
ass-slapping,
back-whacking ball and stick.

"Have an eye," they yell.
"Have an eye pal,
Two men out!"

An outfielder's arm,
I kiss the vein
that runs along the peak
of your bicep;
inch over,
rest stop my lip in the groove rack
of rib
just above the
rise and fall
of stomach;
nose dive, kiss
the sea-salt twitch
as you turn again
and grumble.
I love you I say
to your hip, thigh,
and ever-so-swollen knee.
I love you, I say
to your calves, ankles, your perfect size ten feet.

THE KISSING MAN

for Jackie

The kissing man came to the door
Selling his wares,
Muttering under his breath:
"Look at this beautiful day,
The world is so full and rich.
Wouldn't you like something to enhance it?
Something with the power to engender love?
I have flowers from Japan,
Orange blossoms, stuffed bears from Hokkaido,
Rain forest fuchsias from Costa Rica,
Fragrances from Nepal.
(Here I should pause.)
But you, someone so beautiful as you,
Only someone with the tenderness in your face,
Would treasure this rare and precious gift.
I cannot show everyone since I have so few.
(Here I should display what I want most to be rid of.)
Yes," he thought, "that will do."

Then she opened the door
And he stood there unhinged,
His mouth slightly open
And his mind sang:
"O beauty beyond all reckoning"
And "Gosh," and "Hot damn!"
"Oh," she thought, "it is an idiot
Who cannot speak, come to collect for the poor."
When she turned to find some rags
He collapsed to his knees and croaked:
"Wait." When she turned to him he said:
"All that I have is yours.

All that I ask is that you give me this day,
That I may spend the day in your presence,
And if you wish, I may hold your hand
And if you wish, we may find our way to a kiss.
I want to rejoice in the sound of your voice.
The sweat of your palms is more fragrant and rare
Than all the vials I have from the Orient.
And if God would be so good, so good and gracious
I want the blessings of your lips to rain down on my flesh
Like the descending wings of the Holy Spirit
Crimson dove, flushed by the infusion of this bliss."
Then he stopped and held his breath
Shamed by his boldness.
"But none of this is necessary."
He said as his gaze fell from her face
To the dust of the dirt floor at her bare feet,
"All I ask is that you give me this day."

CREAM THEY SAY

rises, blank and white as an inch of snow
over the simple pastures of milk.

It is to be treasured, turning this way
for luck, sweet as rock candy, or turning

sour. Like head on the body of cool gold
beer, the perfect foam tipping into a

red mouth. The mouth quivering. Could I be
so easy to love? Think of it. The blue

ice white that froths up into a cloud,
all goodness, only to be reaped. It is

something I've never seen, but like so many
happenings graceful and unfathomable

I believe in it. Cream. The empty churn
as it lifts itself without thought,

without motion, to pool into velvet.
And white. Like an untroubled face turning

in its sleep. A moon that sails through
my window, speaking quietly and never

for long. I believe in it the way I believe
in magic. The way I believe in the soul or any light

that breaks from common day. The way I believe
in you. So I'm waiting for you to gather

together your currents, your eddies, the whole
glistening tide of your body and swoon

up at me. Or out of me. This miracle
I have seen. Your mouth, your sweetness,

your trembling harvest that lingers but does not
stay. Rise tonight. Shine in my arms.

THE COMB

This black comb smells of sex.
Of the time you smashed the radio
in the middle of Tina Turner.

Of the way your hair rides itself in the rain
when you walk with your head down.
You carry your gym bag with purpose.

There you are in the locker room
too shy to look, but don't bother
to hide yourself either.

Your shampoo has spilled
—all that blue-green
and you still don't have a comb.

Will you borrow from a muscular swimmer?
A sit-up maniac?
Ask him while you're wet.

How Men Fear Women

Because I couldn't stop her flying,
I joined her where she leaked wet music,
entered from behind and below,
watched her shoulders bunch and tent and spread,
held her working wings,
slip of bone and meat to beat down air,
saw her spine leap
from the hair of where I joined her
to bury itself in the part of hair
at the vulva of her skull,
and she warned me:
Don't look down.

I looked down,
and clenched her wings to me until they snapped.
When we fell,
I drove up in as far as her heart.
It stopped me as it stopped,
took me in its open fist
and held on as I shook free
the last white drops.
She turned beneath me then,
leaned back on wings that broke again
and broke again, crackle of burning straw.
And when I raised my eyes
from her blind, staring breasts,
she warned me:
Don't look up.

LONGING. SILENCE. CAN'T SAY

evening —
and the ink dries
on my grinding stone
 —Ann Newell

CLINT LONGLEY,
that's who it was.
That Thanksgiving game
so many years ago.
Until just now,
I'd always been able
to summon his name
at will.

This is happening
more and more.
And I'm only 42.
 —Frank Hart

How Can I Follow My Beautiful Dreams?

"And what could he say?
And what better could he do?"
—Robert Desnos

I left Iowa one Thanksgiving
many years ago to be able to say this
so many years later.
I had choices and I took them.
First, a painter on a busy road,
then I married Guadalupe and we built a house.
I fixed the faucet, then broke the sink.
I laid a patio for rows of flowerpots
in which we planted cilantro and dill.
One long job of pungent blossom
held in place by the crescent moon.

Beneath the apricot tree,
I remember old mistakes,
those love letters written on a crow.
How can I follow my beautiful dreams?
My samba, my bossa nova,
my little calloused halo
I take so seriously.
Last night, my nightmare
was that I had nothing to lose.
I remember pinetrees in the snow,
alone in a sleeping bag, and lost.

I have obsessions, I have a penis,
this red handkerchief full of onions,
a sacred telephone, a crazy squid
of attachment and promise.

What web of nourishment do I stand upon?
Veins of water in the fissures of living rock!
And how do I serve it?
When I lift the rootball
above the freshly dug hole,
 I'm on my knees
 grumbling to sky and dirt.
But sometimes, in Spring, I whistle.

Someone might mention
that I rarely write to my mother.
Will my own child be so callous?
As I cradle my sleeping daughter,
 there is no axis
 other than this grasp.
Not one moment more dear, nor daring.
I bet my life as a man on this.
 As a pivot of failure.
 As questions in the morning sun.
 As if this world
 is really all there is.

I work as best as I can—
a frugal sweatshop:
 thickbutt, curveball, backache
 ruddy squinteye,
rounded by gravity and consequence.
A majestic geek
 of ambition and muddle.

So much folly—
 at 20, knocked back by bad war
 at 30, bad love
 over 40, on the lookout
 for rogues and scoundrels.

I want to be a teapot,
pure vessel, a decent spout.
I'm both a mama and a talking horse.
To tame all cravings I still crave
 my sturdy black
 barbeque grill.
Fire fire fire.
Born of this world
 and brought to the table,
in loveliness,
 a church taught to cook.

My brave train rolls forward as it must.
To remember how to kiss
 is my simple practice.
My beautiful beautiful dreams
summed up in the word "and".
 I'm lucky as a shovel.
Full of palm grease and accomplishment.
A jar after the jam—jammed with zinnias.
So what if I'm half a goon!
 I'm still able to walk all day by the river,
 ecstatic to wear my hat on backwards.

A FOURTEEN YEAR OLD BOY WALKS INTO THE BLIZZARD

Maybe it was something she said on the phone,
Or the way she said it, that drove him
Out into what turned out to be the worst
Blizzard the county had seen in eleven years.
Even Doc Shalpin closed the pharmacy.
The storefront was dark when the boy walked by
On his way to her house—her parents' house—
Just up the hill three miles.
Three long cold miles.
He saw only two cars the whole way,
And one city truck with a snow plow,
Laboring under flashing amber light
Barely visible in the dense driving snow.
Still, he pushed on. Provoked by something
He couldn't explain, but at fourteen,
Could feel for the rest of his life,
Something he knew he couldn't let
Her father see. So when he got
To the house and saw her father
In the living room, reading the paper
And tapping a pipe, he didn't go to the door.
He stood across the street and watched the house,
Watched the snow drift and swirl,
And later, watched his footsteps disappear
Behind him. Leaving no trace.

SNAPSHOTS

He sits alone at the table
in the cabin of a friend;
hurricane lamps drive the dark
from the rough pine walls.
This is the life he thinks.

Watching a river streaming south
breathing the chill damp air,
a night unfit for anything else.

He is listening to Bach, two-part
inventions for harpsichord,
drinking gin straight and seriously
as a lone drinker will.

He pulls photos from an album,
pictures of his wife.
In one of them she is standing
at the kitchen sink
half turned & smiling.

Behind her, posted on the fridge
a child's drawing with words
a picture of a man smoking a cigarette.
He knows the words by heart.

"I like my dad mighty fine
I wouldn't trade him for
anything in our whole solar system
not even for a small tan pony."

He is burning the photos of his wife
one by one,
feeding them into the wood stove.
Each picture
a walk in the past with strangers.

The room is hot;
he opens a window then a door
taking a drink from the bottle he
removes his shirt, his shoes, then
jeans, socks, underwear.

He has put too much fuel on the fire
or set the damper too high;
he turns the music up loud.
He is dancing naked

arms extended in the yellow light
round & round the room.
A deranged marionette.
Yes, this is the life he thinks
and drinks the last of the gin.

He walks onto the deck
overlooking the river;
he takes a leak, then tosses the bottle
out into the dark swirling water.
Another dead soldier, he thinks.

MARRIAGE PROPOSAL

for Jackie

1.
Consider
the movement of people
across the face of the earth.
A bar in Brussels named Andalucia.
Narrow streets in Paris where Arab vendors stand
shivering beside a flame.

Consider
the walk home from Minnesota
when we were turned away.
 "I'll never work the fields again."

Remember Nancy's father
the marine after Anzio
changing his name from Simioni to Simmons.
Left his mother's saloon (Le Rendezvous) in West Virginia.
 "When I first came here I was so lonely.
 One night I walked into a bar, sat down, and cried."

The experience is common.
As likely the figlio gone as the immigrant
from Nuevo Leon.

2.
Shouts and laughter in the darkening street.
From every passing stoop
the fragrance of supper warmed.
The widow Agnostelis asks a favor
of a tired man walking home.
The door opens, the family gathered
a beer with the evening news.
Some father in your past
sleeping in the tendrils of your blood
stirs with every scent of newborn flesh
jostles with every sound of someone loved.

Murmuring a mother soothes her child
shrinking from the touch of tepid water
then relaxing into its warmth.
Pursing lips emit a slavic sound.
Wislawa grasps strands of hair
falling from the looming face above her
and kicks, flails her infant arms.

3.
My father is a happy man.
There was never a thought in him
of the law or medicine.
Fertile hens and lambs in their season
feeble kids dropping into the dust as they're born.
 "Look, isn't it a wonder, a blessing to the poor.
 Birthing two at once or more."

No wealth, no sure and certain future.
All I can offer you is a love as common as flowers.

ANNIVERSARY OF THE WAR'S END

amazed you could be
safe at home
you feel yourself pondside
on a boyhood road
tangles of coarse grass
through your pants
the smell of the churned bank
sharp in your nose
you singing in a clear voice
holding a note
in the littered American clearing
the geese flap great wings
green-headed mallards lift together

your grown sons arrive at dusk
road-weary smiles white in unshaven faces
 maybe it's the all-day news
 making you remember other faces
 on double-canopy plantations
you shudder to see your boys
at this once soldier's age

pat their shoulders
hug the oldest first
but there's no playful wrestling
like when they were boys
no forcing them to bend a little
losing balance under your grip
and while you talk
of fog and night-driving
talk of the truck
girlfriends and work
you don't say it shakes you
that you came home
with anything left in you
to shape into such
sweetness as these boys

DRUNK, WITH ROSES

He stumbles a bit on the porch step but
manages to slip the key into the lock.
In his left hand he grips roses,
their heads flailing about,
dark flawless petals shaken
like altar boys in an earthquake.
The bourbon has settled him, cleansed him,
he hurries, knowing again
what's important. Booze was
an anaesthetic against the sting
of the words they gave each other,
he cried out within himself for ease
from pain. But now he feels
how tall and green the trees stand,
how unspeakably beautiful
the clouds that pass overhead between
the roofs of houses. His clothes
are disheveled, he grips the
green stems tighter, hoping his passion,
so empty of words, will find its way into
these red ones. Crosses the kitchen, no longer
afraid—having come to
a deeper fear that became
door to an ecstasy that had settled
unnoticed like some household smell
down around their life.

On Meeting a Former Lover and Her Newborn Son

Whatever I said when we parted,
no matter how true, was probably a lie.
But to you that means little now,
happy and desperate for sleep,
too much to do the rest of your life.
You talk easily with me at last;
your son tells you how unimportant I am,
and he's right; still, I can savor regret
for what I'd never change: one more woman,
you, impatient with my slow integrity
or the words that passed for it,
your son one more child I might have fathered
and did not; could still be father to, and am not.

In my safe inconsequence I'm glad for you
because I can afford to be,
or simply because I'm glad, because you are,
and I watch the flicker of your son's changing face
with the dumb, honest wonder of the man
who stared deep into the first flames,
unable to look away, terrified and grateful for warmth,
aching to take fire in his arms no matter how it burns.

CRANES MATE FOR LIFE

Cranes mate for life
but a woman goes to the well
and never returns

Something in me
does not want to stay

When the city is quiet
I hear the sigh
of dreaming bodies slowly turning

In the morning the father leaves
and his chair at the dinner table
stays empty

There is no other land, they say
no other life

Who then is calling me?

GENTS

In the Gents room between acts
at the Regional Theatre, talk is corn and beans,
the drought not a lack but a thing out there.
We're all on line to go: one guy asks
after his neighbor's chickens, prices at the yard,
but clips conversation to fix
his stare to the wall. It's something
not to see, his body posted and tightened
into privacy, gone invisible. Like how
the houses here grow their windbreaks:
a quiet thicket of blue spruce in the middle
of a field, and no one will ever
notice us, hiding in the open.

An usher goes by, ringing in Act Two.
Soooey says a voice in a stall and all
the Gents laugh. It's a revival,
the seats harder than remembered,
cushions rent for 50¢ and everybody pays,
joking about the tax man. And the lights
go down, the other play resumes:
the Gents sit up in their bodies,
scattered about the house, waiting for rain.

WHAT MEN TALK ABOUT

Robert, stretched out on the cot,
reads one of his new poems aloud

for the three of us who are
scattered around the room

his voice rises and falls until
he sings the final triumphant

stanza where he gets the girl with a
mix of Dudley Doright attitude and

Casanova technique. He finishes and
we give the nod of yes, the yes of

friendship, and take another drink,
beer for Alan and me, bourbon for Tom

who needs this weekend more than the
rest of us. Now Tom riffles through

his notebook and reads a poem of
longing—a sad refrain—I want a

woman, I want a woman, over and over and so
on we go. Alan is all cars and re-reading

Henry Miller's *Rosy Crucifixion*.
Between beers he and I break into

"Freedom's just another word" and
I am beginning to babble about love

and the evils of war and so on
we go taking turns bleeding and

boasting, boasting and bleeding,
together we men.

SLIVER

In the dark, she shivers in his arms,
hurt, wild—like that great bird
that crashed through the living room window
last Christmas—droppings, slivers
the whole way into the kitchen.
He'd cradled it wearing gardening gloves,
it only shuddered. Now, nothing he says
quiets her, stops her asking:
am i pretty? am i smart? am i all
you dreamed of? as though she doesn't know,
as though he is her mirror,
she is pounding, pounding the glass.

THE MASCULINE ART OF LONGING

In a cream-colored room with blue curtains,
a woman in long skirts gazes at her lamp.
She perfects "the art of longing." In poems I have
gone with her to that room, escaped with relief
the travail of the fathers, their difficult
beauty, made no room in my words for the wood
they chopped, the cabbages they grew. Now I see
their hands, the nails squared, earth biting down
in the furrows. I smell the stew of tobacco, hoe-
handles and sweat, and today I long to go down
in a dense atmosphere of men working, the stone
that sinks below those lilies floating on water.

FOR WOMEN WHO WONDER
AT THE MISANTHROPY OF CERTAIN MEN

Maybe men can afford to malinger
in the realms of the dead
can buy those fancy honey cakes
for the hungry dog whose lascivious tongues
loll past his three sets of sharp teeth

Maybe men like his dangerous bark
and the way he settles down
like a comfy old hound back home
once a man feeds him

Probably they know they've got the coins
for their eyes so they can get
across the dark river to the place where
guys play soccer all day long

Maybe they like to bargain
with the grizzled Greek ferryman
the two of them sitting in the boat
arm wrestling till their veins stand out
and slapping each other's hands

Maybe they don't mind drinking blood
and reminiscing about the houses
crowded with new people
their wives kept helping out

Probably some of the new people
will be boys anyway who will join them
lamenting the uselessness of life
soon after their mothers kiss their lips
and teach them how to speak.

THEORY OF TEARS

Tears come from tombs.
They condense on the granite tombstones of Vermont
and hitch rides west on the faces of women.
The tears of men come from the sides of skyscrapers
and the faces of shovels left out overnight.
Tears are more related to dew than to rain,

more to oceans than to lakes, and of oceans,
they are more related to the Pacific than the Indian
or Arctic, because of all the memories the Pacific stirs.

If you tasted the tears of a hundred women, you
could not tell them apart. They'd have a childbed
taste and a whiff of soup in the bouquet.

But men's tears, because there are so few shed
are so concentrated, so individual. You can taste
a desk in one and a tractor in another. One tastes

of mother and the other has no taste, because he has saved
all his tears for a million million years, like a God
of tears, a full diamond walking hard toward a horizon.

SLIABH, LOCH, AGUS FEAR CE TARAING ANAIL IAD

translation: Mountains, Lakes, the Men Who Breathe Them

Two old men bend toward each other
In a pub in Glasgow. One
Hunkers down in his coat—the collar pushes folds
In his neck—it is cold, and night comes early.

The other (who can speak only Gaelic)
Breathes heavily, looks inward,
And knows it has been this way
Since the mines.
He tells stories about his life—
Bringing up from the dark,
Black rocks. How he has become so rock-like
That there are times, at night,
Alone, he will cough up blackness.
He has been too long in the mountain.
He has taken the mountain in,
And it wants to go back.

At night he knows.
He can feel the heaviness in him
So deep, it is as if he were at the bottom
Of the earth, and somewhere above,
Through the immovable black,
Eyeless creatures have been moving for ages.
The mountain has been here,
He has been here, for it all.
Riding the rock melting heat beneath.

WHAT A LEAKY BATHROOM DID

I.

My fears arise within me like the sun
that still appears on cloudy days at the horizon:
though it rains we know it's there.

I rage about the house and, screaming, shake the walls
that I have painted shades of peach, and scare my wife
who sees my father's ghost

rise up and stalk the halls, hold me hostage with
his twisted life. Yet I'll play host to nightmares not my own;
if I could exorcise his demons with a knife

perhaps I would not feel so lost.

II.

The whole moon slides across the heavens
though we only see a sliver.
The stars we wish upon could centuries be dead.

The wishes that pass our lips could easily be lies.
But when I wake the skin's my own
there is no other.

The dead can only echo what I've heard before—
I should let them sleep, put them back in photographs
hanging on the walls—

and take a walk in autumn air.

WORKING

this spring rain
the thief too
curses his job
 —William J. Higginson

DAY TIMER

Slick and cocky as an old trout
 in a cool green pool,
then scaled and warm, I'm shocked again
 by the razor at
my throat, the need to dress anew.

I leave her in bed, kissed again,
 and the cat watches
me fill pockets with survival
 gear; we're sad, I fear.
I travel the tunnel of dark.

I'm driven daily to madness—
 the concrete towers,
the bosses, artificial brightness,
 and hired drudgery—
daydreaming shamelessly of home.

Of course I survive another shift,

 but I'm not the same:
every day I fade a little,
 with just enough left
to tunnel slowly home again.

INTERNAL COMBUSTION

I'm a responsible man, and so
they load me up. Seems they think
I'm a truck with a big engine,
thick tires, strong shock absorbers:
a little gas, some water, battery acid—
they think it keeps me happy.

But it happens I'm also a lamp
with a chimney of glass
and a bellyful of golden spice-oil.
It happens my tongue is a wick,
and when the longing
flames out from my furnace heart,
I speak, and those who listen
burn. Or I don't speak:
I swallow the fire,
and it sinks down writhing
in my scrotum like some demon.

It's that demon who lights my way.
The demon they name if they mention me.
The demon who drives me around in circles,
roaring like hell, eating my own sweet dust.

REPLACING A PIECE OF SIDEWALK

After years of concrete contracting
and seeing where men go wrong,
I think back to replacing that first piece of sidewalk
with my father.
Just a boy, I was amazed
at the steady power of
viscous concrete,
that incredible resisting mass of matter
threatening to cast all the errors of the day
in stone,
it,
quickly wearing down my young
arms and legs
into a wash of lactic acid.

He stayed with it through the afternoon.
The rash hills we poured were
flattened.
The time came to finish with
the light stroke of a broom.
Then he looked it over,
like a baker who's just pulled something from the oven;
a sportsman holding up a fish,
half astonished
half cocksure in his persistence.

Everything that day needed relearning
later as a tradesman—
except for one thing:
 men give up too soon

CONSTRUCTION LINGO

for Scott and Ron

Jacks and Kings and Cripples
Horsefeathers and Crickets.
"Plummet," the boss shouts
and I imagine workers falling
off the roof on command.
But he just means "plumb it,"
meaning is it level?
Is what level?
Why, the crippled headers of course!
And then there are the tools.
Does anyone know what a
prick punch is for?

Paula Farkas

DRYWALL

I hear the men talking
I hear the men talking in hushed voices
I hear the men talking
They are saying, "drywall"
Something conspired, something subversive,
"drywall"
I hear the men talking
Now they are expressing reverence for drywall
Something collective, something tribal,
"drywall"
And I cannot enter the cathedral
of their common understanding
after all I am a woman and
what do I know about drywall?
Still, I hear the men talking
The men are talking about drywall
The women are quietly thinking

77

POURING CONCRETE IN 100 ° TEMPERATURES

I tell them
how it will be done,
this yellow early morning cool.
Roof trusses cast wide bars of shade
inside the solid walls
upon the gravel shining subfloor wet,
across our bodies topaz.
We talk
beneath the open roof.

Below the early faded denim sky
men force the racking yellow truck,
its rough breath passing overhead in acrid clouds,
down the narrow path it must—
tires standing to the
rib cage,
within an inch they pass
from crushing
ribs like trusses,
rafters that hang above our lives
in fragile shadows.

From this twisting hulk
conjured in the unhung doorway,
from the groaning spinneret,
we draw out the lentous thread
hanging green upon the
sunlight,
to our interior where
all the bars of shade
lock us in sweating occupation.
A thickened swamp
where humid mists climb our shirts,
asphyxiated

stones beneath our feet
seeking monolithic combinations;
and as we flatten,
casting off our dripping fetid gloves—
the lake begins to freeze.

Upon another face
notice
how the sun is climbing
its gray ladder,
thinning all the rungs in its ascent
and how we're faded
by our work,
bleached to blue chamisa
and drying portland at our wrists.

Three hours now,
kneeling in this temple
boned and vaulted
caged and prostrate;
the ringing floor forgets
beginnings
and forgives
as all stones do
their assemblage,
the firm purposes of men and sunlight.

At noon I notice
all men gone,
vaporized in temperature and time.
The sun has thinned to threads
the bars
and I escape
the floor,
as from my bed,
in dreams of life.

THE PROPER RHYTHM

To shear three-hundred and twenty head in eight hours,
you've got to have stamina, perfect concentration.
And sharp tools.

So, I ground his cutters thin as old teeth.

He took the blade,
hooked my hand in his to mark the proper rhythm.

From the stone came the ancient steel song,
a whir of wind through guys, a scythe through grass.

Not a bronze song, nor of copper,
but a cleaner, bloodier song.

And the music caught us in its steel web
and we were dancing in gyres of white hot sand.

Angling the cutter against the light,
a paleolithic glint against electric fire,
he pronounced his satisfaction with its edge

and sang: *This will cut a throat.*

GIRL CRAZY

Don't cut the sheep and don't cut the conversation.
Then you'll always have work.
And girls!
You can't afford girls.
And don't get married until you're thirty.
I didn't marry 'til I was thirty, and now I've got seven children.
It would've been cheaper to raise seven hogs.

Girls—no, you can't afford girls.

I never listened,
spent my shearing money like a trail hand
just off a cattle drive.
And later wonder why,
when I told them,
those college girls,
that I was a sheep shearer's son,
they would never answer when I called.

But I always talked to the farmer
about prices and politics,
about children and grandkids,
the dead and the dying.
And I always had work.

LABOR DAY—UP ON THE ROOF

We are working today, although it hardly seems work, such is the beauty around us. We perch on a high roof being roofed, and watch the surfers, the dwindling sun-worshipers strolling the length of Westend beach and back again. To shape the mood, tapes jammed into the work radio blare a cacophony of despair, love lost, and ruin. AC-DC, Allman Brothers, and Jimi Hendrix suit the muscled cadence of construction work. If Mozart is a verdant drink of calm served afterhours, then Hendrix, is the hot, jangled daylight of airguns and grimy repetition. The sweet music of lily pond and meadow is a stately quadrille, but it will not drive the machine. That requires the hot, oily, frenetic din of Jimi's white guitar.

Explain *this* to the neighbors at eight a.m.

Work segues to breaktime. 10 o'clock. We drink sodas, generic, bought cheap in boardinghouse quantities. Tasteless, yet cooling, they only quench when you have reached 60% dehydration, when you are working, when the ice is piled high in the cooler, when there's nothing better to drink. We sit on the roof and briefly pass the binoculars: the easy pretense of getting a closer look at the cormorants, at the waves which piledrive the riders into sand bottoms like Brahma bulls in a rodeo, at the far horizon where the mystery dragger pulls and cajoles and winnows a boatload of bottomfish.

It's a short break for the carpenters up on the roof. We sit and idle and then get on with it: the better not to prolong the inevitable, to see the day wind down, and to look seaward again. Aboard the distant dragger are young men flush with the bloom of a first real job, working a summer on the stinking, yawing workdeck of an ancient rustbucket. The smell of diesel, of rank viscera, Cuban cigars, the unpunished sweetness of cannabis. Rock and roll fights for airspace against the ratcheting clamor of hydraulics and icemakers. An exhilarating place to be. High summer. Awash in fish guts with loose undercounter money to be made. Men in their early twenties hired on because an uncle or a brother or a friend of a friend who knows the captain says they're OK, that they're steady, sober, and reliable. Young men who pause briefly from hauling miles of Dacron webbing, from slitting acres of gristled halibut and yellowfin, who gaze

wistfully over a rusty leeboard and wonder who lives there on that island. Who's that running on the beach, burning toes on the sand? Who smears tanning unguents onto the lazy, languid spine of the dozing beauty? Who's that lugging cedar bundles up a ladder? Do they wonder, we muse in kindred reverie, if anyone else in the world besides themselves is toiling on this Labor Day?

Yes, it is Labor Day and that got us thinking. The sublime simplicity washed over us like a pebble in the surf, the obviated metaphor of the day and its meaning. What is labor? What are these jobs that people do? And why do only a small percentage loom more important, more revered, more compensated than the vast rabble that is the rest of us? Is it perception? Is it actual worth? Why, for instance, has society skewed itself into canonizing trial attorneys with their meteoric pay scale, yet using the same flawed reasoning, pays our children's teachers less than what a union plumber's helper earns? Why, on Labor Day, can we be served a glass of chablis, rent a car, or purchase drywall screws, yet not receive any mail, cash a check, or be arraigned? The cops have to work today, to arrest you, yet the judge and the clerks get to go to the beach. How come banks close, yet somehow they know if your check is no good? Who in the world is working on Labor Day? Anyone who works on Labor Day does it because he is making hay while the sun shines, and for no other good reason. Otherwise the world would cease spinning and fall from its axis. That is science.

This is the moment of pure epiphany, the secret harvest of pleasure, when it dawns on us that the sad majority of office workers and interior minions will never experience what we experience, will never see what we see. How luscious and extravagant the roof is—within spitting distance of the rippling tide, the sun weighs like a hot copper penny on your shoulderblades, all it's expanse of infinity and promise cast out before us. This is surely heaven, and we have died and come here.

Then we remember it's opposite. How grim, how utterly grim, the city in high summer. The sunless toil, the cool shadows between

office partitions, squinting into the blue pixels of cyberdrudgery. Endless, timeless columns of dreary ciphering made under fluorescent's hard glare. How grim to skulk inside the fear of big city avenues, tires roll over asphalt hot as Jupiter's suns, blinded by glasswalled canyons of neglect's urban fury. How grim to fear for one's life, to install beepers and hooters and buzzers to protect against thievery in a world where thievery is the normal reaction to one of two conditions: greed, or not having enough of this or enough of that. The big picture is that we all working for the same imagined rewards, to please the same imagined overseers.

Except that today we are here under God's white sunlight. We are tired and dusty from the roof. The questions of each day hang in the air like colored balloons. The unknowns, the blind pursuit of a job's completion, the nagging riddle of "Will we be paid?", "Will the winter be kind?", "Will the truck hold together another year?" We unplug the compressor, coil the hoses for the morning, which, as lovely as the evening may be, will come tomorrow.

At the Railyards

men
gather at the railyards
groups in rough faces
assemblies in parks
half moon circles
nervous conclaves
narrow pools of men
in parking lots edges
murmuring male magic
waiting for the sun
to crest the east
mountain morning
that reflects in the
longing surfaces of the men
as they men wait
for the boss man to
arrive pick them for
day labor manual work
yet are these men
national mexico proud
and mustly anyone +
wo man could admire
the lean fire of these
men.

WORK

Work & the cruelty of bosses &
the daily injustices & power
how power grinds, grinds, how power
pulverizes, pounds, pounds, & how it's all like
hammer blows, like fists

& how it molds the body, shapes the shoulders,
the spine & twists the nerves, knots
them & yes, I have kids to support &
I'm being laid off & sure tell me
about it, buddy

& how you try to be the best you can be
& you're one step from the street anyhow
& what you really want is to ride hard
& die free
& anything but this window
looking out at an empty parking lot

But I ain't surrendering, I got a big smile,
and my baby loves me Cadillac style, yeah, sure

SWEATING IT

They call me fatso/ I'm eighteen/ wearing a halo of pimples/
banging the '48 Chevy wagon around Mount Vernon/ squealing
the tires/ stripping the gears/ triple parking so I can unload
and hustle back to re-load/ I throw groceries through windows/
on T.V. sets/ in playpens/ always shark-smiling for quarters/
I'm yelled at for being late/ for being early/ cause the fruit's
hard/ the ice cream's soft/ but I'm not/ staring at the
customer's legs/ their tits/ trying not to/ desperate to grab hold
before I drown in my own hormones/ summer Saturdays are the
worst/ all day up and down the housing project stairs/ (the
elevators, shorted out by piss-firing delinquents, go nowhere)
sweating I ask for a drink/ ebony lady laughs/ says, "Sorry, my
faucet's labeled 'Blacks only' "/ gives me one anyway/ I screech
back to the store/ my father's chasing a thief out the door/ then
me too so I can study for finals/ dad collars the crook/ kisses his
kid/ I bus home on the number 16 daydreaming sex/ money/ a
dynamite complexion/ standing in the aisle in the guise of a
disheveled old cleaning lady/ is my Fairy Godmother.

NOSTRADAMUS OF THE MACHINE SHOP

Because Fred has a sense of humor
I buy him holiday boxer shorts:
for Christmas a pair
with palm trees and surfing Santas
wearing sunglasses on them,
for Valentine's Day some shorts
with lipstick kisses,
for 4th of July some
with red, white, and blue
bombs bursting in air,
for Halloween I bought him black ones
with skeletons that glowed in the dark,
and I almost bought him the ones
I saw at Frederick's of Hollywood
with Pinocchio's face on the front,
the nose supposed to be a you-know-what
poking out the fly, but there
is no holiday to celebrate wood or liars.

But even though he has a sense of humor,
he won't wear any of his holiday boxer shorts
until his other shorts are used up
and some used up a couple extra days
and I ask him, "Why won't you
wear your holiday shorts more often?"
And he says because he doesn't want
any of the machinists at work
to see Santa Claus or kisses
sticking out of his jeans
when he bends over to pick up a Hartford chuck
and I ask how do you know
what goes on behind closed doors
or what goes on inside those
machinists' greasy Levi's?

How do you know that that tattooed
biker machinist doesn't wear a pair
of Valentine shorts with big red hearts on them
that say I love you?
How do you know
that your cigar-chomping Lead Man
doesn't wear a purple codpiece from Frederick's
with sequins all over it?

And Fred answers, with his infallible integrity,
his unwavering wisdom,
a Nostradamus of the machine shop,
"Because I know they don't."

GRAMMAR

When I first began teaching he asked
which was proper English: *I shore sheep,*
or I sheared sheep, or I have shorn sheep
or I have sheared sheep.

I said: *shear, shore, shorn.*

He said: *I would have sheared all night,*
that sounds right.

I sang: *I would have shorn all day.*
I would have shorn all night and still have shorn some more.
That sounds right.

He said: *shear, sheared, shorn, shore.*
Eat your sandwich.

It was the same peanut-butter sandwich he and his sons
had ate, eaten and been eating for forty years.

COWBOY POEM

This poem rises before dawn;
guzzles strong coffee; gobbles eggs
over easy with bacon, grits,
biscuits, and red-eye gravy; then
begins its day of lonely work:
riding the line on the mind's ranch,
keeping the words under its charge
on home range, pulling them from bogs,
tending to their various ills,
protecting them from predators.

This poem in the saddle goes
dashing, rolls its own smokes, sometimes
may need to take its guns to town.

This poem has an evening sip
of whiskey, ponders the long view,
sleeps in a shack under clear stars.

This poem has a quick and wry
sense of humor, gets the job done,
dallies its rope, dallies its tongue.

WHY I AM A POET

My craft is the emotions. The ship I build
Is intended for starry nights and open water.
Nights where barefoot sailors stand and wonder
How will it end? Will we ever see the earth again?
The drift beneath our feet carries us to our deaths
And to blossom teeming shores beautiful beyond our imagination.
It is the work of my hands.
Carpenter hands my father gave me
Call to every piece of work
To the fruit and labor of this earth:
Here, rest here, in my palms.
Each strike, every flail, a tenderness.
I will build, will strike and shape
Will nudge and nestle to their peak
The startled doves of your emotion.
I will take your breath away.

Depends

When a man does
"woman's work"
something special
happens. Some look
to the ground,

not his eyes blue-grey. Others
say "how nice" and
"such useful work."

Or, they say nothing
when they come
into the room,
watch
the way he can

change a diaper
— the wet white lotus —
on a grown man
with a single gloved hand,
serve Ensure

with the other,
the crooked straw
never misses
the crooked
mouth

even when the head
and neck do not
want to bend.
Dust does cling
to the gauze underside

of the four-poster bed's
mattress
is his first surprise;
soap and hot water
do wrinkle hands

is his second.
He is bone tired
yes,
to the bone
and wants to cry

and the daytime Soaps
don't always do
the trick
even when Phyllis and Danny
fall in love

and out of again.
And *Ladies Home Journal*
can only do
so many things with Jell-O
cheese spread and crepes.

And he can brew
good coffee
and wash shirts
and still look good
in this look-good-mirror

a glow
in his cheek, line of red
on the horizon
of his left eye, dirt
like mascara turned bad

in the crooked
right.
The sun
sets lightly
behind the gold —

glass condos on Bay.
At home,
he meditates,
sips ginger tea,
tries to see a day

well done. So many
men in flannel pyjamas,
bulky baby bottoms,
brand name: Depends.
Some naked, tail bones

bleeding. They
spend all day
in bed
seventy-four dry grey pounds
of rage. Red

is a bed sore
on a bone near dead. And
Bill's arm will not bend
any better
than yesterday.

He imagines Richard
in leather harness
where he is most
at rest
and Wade

one more time
in Patsy Cline
who's-sorry-now-boozy-drag.
And Bill was in
the army,

still shouts "a-tten-tion!"
Bill so far gone: Where
is your mother?
She must be dead.
The fathers are never

here —"important
work to do,"
but the mothers,
with knitting, soup
and McMuffins always come.

And you have to wonder:
 if mothers deliver sons screaming
 into the world
 who then holds them
 crying out.

A Warrior of the Times

(protesting the military's policy on homosexuals)

I have run the gauntlet of the brave
and driven chariots to fields of war.
Weeping, I have carried you, my brothers,
through eons home on heroes' shields.
I have stood with you entrenched in blood,
curdled dark and sour by our trembling hearts.
I have shielded you as you lay wounded
upon the parapets of the righteous
and then held fast your marbled hands
as your departed spirits soared and waved good-bye.

And all the while, yes, all the while,
through all these cascading ages,
locked in battle, side by side with you,
I have borne the woes of centuries in silence.
While you have clutched me round the shoulders,
gripped my hands and sworn yourself
to lifelong loyalty, you have never known
that you knew not the hidden truth of me.
It was, indeed, the ways that I behaved in war
that earned your love and admiration.

But now at last that time has begged me speak,
and I who long have held the secret trust
have asked to be accorded earned respect,
I find that you recoil from me in fear and anger
as though the centuries in arms have mattered not,
as though our agonies and triumphs shared
have suddenly withered on the winds.
It saddens me to see your shallowness revealed,
but I shall tell you now, the time has come...
and I am now a warrior of the times.

THE GERMAN OFFICER INHERITS

My dear predecessor,
these three days have proved
eventful for both of us:

I moved to a new apartment,
you had a similar
upheaval of relocation.

May I remark that although
the curtains look washed
and no dust adhered to my gloves,

carpets were littered
with bits of cloth, buttons,
a doll losing stuffing,

books foreign and torn,
tatters of scores…
Smashed glass cut my heel.

Vital silver was missing but
my wife found matching
forks at a pawnshop.

She had a time straightening
the rooms! At last even the dolls
on your daughter's bed are aligned.

My little girl is charmed.
My son is annoyed to find
nothing of interest for him.

But in essence, the flat
is satisfactory, and I
compliment you on the Meissen.

It's the violin, though,
I wish to discuss.
My wife insists: sell it,

our daughter is tone-deaf,
our impatient son
already snapped one string.

But my Great-Uncle Franz
played the tuba. As a child
after Sunday mass I heard

his band in the park,
often thought: how nice
to play some instrument.

My problem: procuring a teacher.
I called the conservatory,
what remains of the symphony.

A few instructors of course
went to the Front. Others
simply vanished.

My wife complains that these days
I've helped with the move
are my first leave in months

so how dare I imagine fiddling.
And such difficult scores!
Still, when I retire…

Should this letter reach you in time
would you be so kind
to recommend somebody good.

HUNT AT LANGLEY

I have nothing to fight with. Am
taking to the woods. I
cannot wait for you...(white noise).

After the slaughter the White House ordered
navy task force destroyers
to move in and pick up stragglers,
men in boats, on rafts, wounded
clinging to bits of wreckage.
A reconnaissance jet spotted
a few survivors
in the water, on the beachhead
only vultures.

At Langley,
we wept silently. Never
had I seen
a room full of men
in tears.
Someone remembered Niño Diaz
and his mutineers. His ship
was ordered to the U.S. naval base
at Viques Island where the marines
disarmed them. We wanted
no more trouble from Señor Diaz.
The president agreed to meet
the six C.R.C. officials. All
had sons, brothers, nephews
in the brigade. I thought
of Tony, Miro, and Dr. Maceo
and tears rolled down my face.

"Will you escort them to the White House?"
I can't face them; they trusted me
and I can't face them.

Dulles, Cabell, and Bisell
were summarily dismissed,
thrown to the wolves
to expiate administration guilt.
The White House whitewashed
the New Frontier by heaping
excrement on us. Privately,
the president vowed
to splinter the agency
into a thousand pieces
and scatter us to the winds.

I issued one more war communique
denying there had been an invasion,
only a resupply effort to the guerillas
in the Escambray, and the landing party
had reached their comrades
when in fact they
were dead,
imprisoned,
or struggling through the Zapata swamps.

Sick of lying and deception,
of political compromise
and military defeat,
I went home.
Peeling my socks off
I realized I hadn't changed
them in a week. I couldn't eat.
I showered, slept, still
couldn't eat, fixed a martini
and another and another and wept.
This was the worst thing
since we lost China.

KIDDUSH ON THE TURNPIKE

Friday night, he brought
challah, wine and paper cups.
He made a tallis from his shoulder belt
and dovened to the rhythms
of passing trucks.
Money is traif on Shabbas
but a quarter in the toll booth
keeps the mitzvah
of his mission
in gear.

AL FRESCO

alone
he memorizes
the rain
—Thomas Fitzsimmons

"One touch of
nature makes the
whole world kin."
-Shakespeare

SEEING BEAR

Walking Petersburg Creek
the Tlingit's Seektkah Heenuk'w
across the Wrangel Narrows
from the mud-flat sloughs of Mitkof Island
I pass the last cabin
last sign
last mark on the map
& come upon brown steaming mounds of berry scat
piles of gutted humpies, half-chewed, fins still twitching.

Through skunk cabbage rank with growth
& devil's club waiting in ambush
its honed thorns prickly with menace
I skirt innocent gooseberries
expecting the worst
prepared around each bend for some dark hulk
swatting fish
& the ultimate terror of Ursus horribilis.

Thick groves of old growth
soak up light
& squeeze out shapes
the stab of strange limbs
flicker of breeze.

No quick exit out this maze of Sitka spruce
tangled arctic bog
muskeg carnivorous with quivering insects
caught in the sundew's last embrace.

Lost in this still untamed Alaskan bush
where two-leggeds have no more weight
than the meat they carry on their bones
puffing my tin whistle like a Webelos,
clapping hands
singing out of dread not joy

I keep seeing the hundred hides of Death
its snout hairy
fangs bristling
about to attack.

Shadows leap out at me from the brush,
startled
hungry
rearing up on hind legs
so near I can smell their panic
wild as fish breath
murder growling in their fierce gaze.

To run or play dead?
Bruin gone berserk & bounding towards me
slashed muscle
the snapped arm ripped from its socket
claws long as Bowie knives
eyes like smoking volcanoes
its bulk crushing me into the earth.

Seeing hot flash
my whole life engraved on a salmonberry
ground to pulp
in the molars of a steel-trap jaw.

Truth is
walking that trail
I meet no one
neither grizzly nor deer
not even a mouse munching lichen.

The air is crisp
clouds huddled against nameless peaks.

Perhaps for the first time in my life
I am alone
with the dark shape of myself.

DREAMING OF MONTANA

I. First Night

I can see the woman now.

Old women take the land
Into their bodies.
Their fallow faces—

We see them in photographs
And think of mountains,
And other places far from our sight.

II. Second Night

The men don't seem to care
When they make love
To a woman who's bleeding.
But later they'll say,
"I don't trust anything
That bleeds for five days,
And lives."

III. Last Night

Somewhere in the back country
There's a bull elk barking,
His breath flaking
Into mountain forest winter.
The trees know what's coming.
The fir bends,
And touches his horn
As he passes.

CAPE HATTERAS: 1939

I went fishing with my father
in that dream. I have the pictures
in my head: the old Woody crammed
with gear and nested in the dunes.
I have his rods, reels, sinkers,
hand-carved lures. His hip-boots
fit me snugly. This can't be memory.
For where are the striped bass
we've caught? where is the sea's
green membrane? the sea's bitter
blood? Where are the shiny scales
that should stipple our arms
and fingers? The shore tips
and heaves: stars brush our lips
with healing galactic fire. Father,
can you feel the briny stars
on your aging body? I went fishing
with you in my dream, and you reached
into the dark waves to teach me,
you walked the twilight beach with me,
you released me from my anger.
But it was death we shared, not life.
Can you feel the tide run now,
its churn and ebb? can you hear
the storm pound the sand with rain?
can you feel the line scream
in our bleeding hands? Have I
hooked you, father? Will I land
your heart at last?

FISHING AT NIGHTFALL

I guess my grandfather's love for fishing
Never rubbed off on my father,
But the last time Dad visited,
I took him to the creek anyway.

The rod and reel looked awkward
In his hands,
And after a dry spell
Of no fish, small talk, then silence—
Aside from my reluctant advice:
use a slow retrieve
but keep it off the bottom
or you'll snag on the rocks;
nothing's working on the surface
so we need to fish deep—
I decided to try the other bank.

Out of respect for locomotives,
I practice a cautious ritual
When I walk the trestled tracks;
I stop to check the lights,
Always look ahead two ties
So as not to be deceived
By the currents below,
And listen for the train
Whose horn I heard as I reached the other side—
Still ten minutes to the south.

My first cast sailed in a long arc
Toward the sinking sun, falling
Halfway between me and my father's silhouette.

The train's engine now a distant droning,
My father's casts falling short in the shallows
Time after time.
I feel a sudden burden and set the hook
As the tracks above me tremble and ring.

I yell to him that I have one on,
But it doesn't really matter.
I feel the freight train bearing down,
And he's over there working out tangles
Reeling in hook after empty hook,
And he doesn't hear me.

The tide keeps rising,
The water between us grows deeper, darker,
And the freight train roars across the creek,
Barrels into my chest, explodes up my spine,
And rages on relentlessly
While we stand, obscured by nightfall,
On opposing sides.

THE MUSKIE

In our parents' yard, a twenty-three pound
muskie's silver body hangs from your stringer.
You have me touch the pumice-like ridge
above the gills. The white throat gapes,
swallows imagination, like a man's tanned forearm,
to the elbow. I think of how a bullfrog
caught by the hundreds of back-curving needles
on the roof of the mouth would bleed and struggle
inside that cartilaginous case.

Your smile stiffens for the camera.
You became the fisherman
our father wanted one of his sons to be.
Those hours with him, too solitary,
out on the iron blue of the Chippewa
barbed into you while I escaped.
Today you're that fish, both predator and prey,
whose tigered back slides ferally and soundlessly
among the shifting shadows of its world.

Was it something of his frightened cruelty
you'd glimpsed turning in your own current
that July morning I drove up
and found you cloudstruck among the raspberries?
The channel is fast-moving and deep.
Only bubbles escape the terrible garden
breathing at the back of the jaws...
In you I see those rows of cat-like teeth hooked downward
and a drunken fisherman trailing his hand in the water.

River Story

He is in love with rivers—
the deep holes where fish languish,
where water murmurs over rocks,
creates turbulence.

He flies to the Green River,
fords the Brazos in hip waders,
stretches his head out the fast car window,
to measure the depth of the Rio with his eyes.

We follow the snake of the road
by the side of the Conejos.
Attached to cliffs,
he moves down towards clear water.

In the bathroom, there are magazines called
Field and Stream.

He is in love with the river between my legs
where he swam upstream, and I bore our son.
He is in love with rivers which are fenced in, signs
attached to their gates, stating, 'no trespassing'.

He is in love with the tug from his hand, holding a rod,
fish at the end, caught by a dry fly, down
in the eternal waters.
He has a reservation on a Reservation.

On a river in Arizona, he has waited for two years,
to stand on the banks of its inhabitants,
rare Apache trout. He is a fisherman
in love, with river after river.

So many rivers; pouring into lakes, oceans,
streams,
which come trickling by
from the meltdown of snowy mountains.

Taste of smoked Cut-throat trout
speak stories in the belly,
all about the Rios,
how we all got swept away.

Judith Rafaela

Rio Pacuare

The river god emerges from the swirling foam
abandoning his kayak cocoon,
the tank top gracefully reveals
bronzed pectorals, erect nipples.
He smiles and with random movement
flits from passenger to passenger
like the brilliant Morpho butterfly
whose wings catch light
to become fluorescent blue.
The mating dance continues
against the backdrop rainforest green,
white gingerflowers hanging by deep pools.

What thoughts the butterfly must have—
what work to fly and flutter
constant movement, mating on the wing.
The butterfly knows its insect nature.
Without the light and flight
dark winged crawly thing
with misformed legs.
So does the river god
beer bottle in the evening
watching T.V. sports
think thoughts of futures
past swollen knees and
tourist demands.

RIFLE RACK

Yesterday, about to pull out of my driveway, on my way to the post office (where I would pick up your letter) I had to pause to let a big white pick-up truck pass—rifle rack in the back window, rifle resting upside down on the rack, and three young men pressed together on the seat, each wearing the ubiquitous seed cap, the kind the grain companies give out for promotional purposes—Mo-Kan Oat, Kraus Milling.

I saw the backs of their heads—or rather, I saw the area where the cotton cloth meets the plastic crescent that grips the cap at the base of the skull.

These men are designed for speed, mobility, endurance—like their trucks. In California, they might be surfers. Here in Missouri, they are hunters, keep coon dogs in kennels, own aluminum boats that rest on blocks under cottonwoods by creeks that reflect leaves, clouds, bits of cold sky.

Among themselves, these men maintain what seems to be a comfortable camaraderie, but surely that's deceptive.

There are definite boundaries and you do not cross them.

Being with them must be like walking fence continually.

Like feral animals, they can be fierce and dangerous.

The police never take action. They *are* the police!

Last week at the college I saw this written on the wall of the toilet in the Education Department: "Hunting season started today. Now's your chance to shoot a faggot."

I phoned Maintenance. "Wash it off. It advocates murder."

The next morning the wall was clean.

As the truck paused at the stop sign at the bottom of the street, the young man in the middle turned to the driver and said something.

Light flashed on the window.

The rifle glowed like an icon.

FATHER TO SON

He shows him how to string the bow
without breaking it, how to walk
with your eyes leading you first
through binoculars, glimpsing a doe.
Sometimes it takes all day to approach.
The wind must be right, and the light
downwind, steady without distraction.
He holds the bow to his heart,
the wood he once braced to shape
as if he were Pygmalion improvising,
his hands singing through clay
or stone, mahogany or ivory white
as the woman now before him, holding
his hands, her breath a pulse
at her temple, the trembling
of muscles drawn tight, now holding
his creation and the very air
he too has created between them.
As if she were a deer in the clearing
he takes his time with her, follows
signs, tracks in grass, slips into
shadow, taking all the time a man must
to approach this moment, the bow strung
tight as emotion, the hunt that seeks
another heart, while silence holds
its own bow, one we cannot bend to break
except by bending it slow, with love.

TIDEWATER SPECIALTIES (FALL/WINTER CATALOG)

for my father

On the cover the man leans to his gun,
his dog poised with her paw lifted, ears perked.
Above the frozen reeds the goose glides toward them
open for landing, wings thrust back.

What I saw were the heavy bodies
strung by their feet from the clothesline,
the delicate, tapering heads;
you in the front hall breaking the back of your gun.
For years it's worked to hate hunting
and the sweet smell of gun oil on yellow flannel,
to study marshes where purple hoods defy snow,
where mottled rails slip through windy grasses.
I've kept those marshes secret.
I still can't wear that pin you gave me,
the two gold geese flying.

SKINNING THE ELK

"There's a lot of life in these animals"
George nods almost like a prayer

as I hold the hoofed leg steady
for the knife mist rising

from the gutted belly skin still warm
Tempered steel peels back thick hide

fur the dark meat of the interior
Secret organs slide steaming

into full moonlight on the bed of
his battered pickup I can't stop

peering into the glazed crystal
of those antlered eyes two perfect

rivets welded to the girder of that
skeletal moment when the bullets' magic

cut life short Later when I try to
wash my hands the blood won't come

off There's no mistake I am
marked for life I wear the elk's

tattoo as its meat becomes my meat
& its blood stains my blood

Spirit leaping
from shape to shape

ONE SUMMER DUSK

the bull got loose, somehow,
from the steel chain that had dragged
on his slobbered nose ring,

(the other end, flaccid,
still attached to a concrete
block on the floor),

tore through the dandelioned fields,
not after cows,
broke pasture fences

to cross the paved road,
dodging and dancing,
his famous cock hidden by balls

that jiggled, madly,
like jowls,
until the panting men,

my father included, jackets flapping
the air, cornered and roped him
at the edge of the woods;

howls of relief
belied the excitement
in their startled faces.

What might have happened
had they not forced him back
to his windowless cinder-block pen,

and, like men,
returned
to their constrained places?

ALFRESCO

Floating naked on a rubber raft, I share the surface
of this rural pond with myriad diaphanous creations
absorbing heat and skimming food. All of us are clinging
to this thinnest film of warmest water, careful not to risk
attracting trout with dangling digits or appendages.

Rudderless, I'm blown by otherwise unnoticed breezes.
Puddled in concavities impressed into the rubber mattress,
pond liquid warms with sun and body heat and lubricates
my lazy paddling. Each stroke against this latex-saturated
canvas skin intensifies an unexpected sexual arousal.

Other species dominate the cold and opaque depths below
the surface, hunt and kill. But I'm not that interested.
It is the boundaries that appeal. I am alone but crowded
by buoyant communities of life, am titillated even more
because they're witnessing my brazen act of outdoor sex.

The moist air's charged with our collective electricity.
Eyes closed, I still can hear things whir around my head
and feel the buzz of wings between my thighs. I ejaculate
into the pond and watch with fascination as this host
of air and water creatures pounce upon, devour my sperm.

JOYFUL INTERPENETRATION

uremic droning spring blossoms
milk leaved thistle

sunfields lithe with goldenrod
fiddlenecks flocked paisleys
pinwheels
grass flower purples
gentian aster

I long to lie in the heat
of the sun
flowers teasing me
into nakedness

I long for the warm tongue
of helios' caress
along my taut belly

outspread legs
feeling the throb
of my sun blown phallus
grown tense and tight
pleading for release

and full so full
to sunflower grow huge
shower the sky womb with
blood hot seed

or feed the sucking roots
wanton vines grasping creepers
slake themselves in me

sweet sting of desire
fulfilled in one wasp moment

and not be gone not gone

WHERE WATER HAS BEEN RECENTLY

So have I.
Walked the aspen meadows so full of wildflowers this year.
Gentian that wait 30 years, bloom now.
Throw themselves to pale green petals, spotted, feline.
Field orchids, those showoffs,
doing color tones in a diatonic scale of violets,
the Charlie Parker of buds.
Sun cats move up the steep slopes to mineral pools,
and the heat, in waves,
smoke, scarves, curls down the mountain
like tears along the groove between nose and cheek.
A mountain cries, like men cry.

This year I'm studying men and wildflowers.
Their radiance astounds me.
It's about rain, and the heart's water.
Field's flung to Indian Paintbrush, that slut of a flower,
putting out all summer.
Rowdy next to the demure bells of the Yucca.
And how I opened the sweet purple edged blossom,
revealed the inner creaminess, the blatent stamen.
Holding there bravely for all to see.
Soapy smell, clean, baby after a bath.
The backs of the petals, the color of bruise.

But there's no rage in flowers.
The Tamerisks hold all stages of bloom at once.
From tiny mild white balls to full pinky spikes.
It's so matrimonial,
and the smell, a Westchester backyard at sunset.
There might almost be fireflies.
Instead there were eagles.
Men are too big for mason jars.

We walk through the virgin Aspen in an Arizona forest.
All around us, the erotic sheen of green,
the fragrance of wild strawberries, an echo of past roses.

You and I and Steve wonder how elk can run through dense woods,
and not lose their antlers.
I stop, alone, and study the dense trees.
Suddenly I find the way of elk through brush.
They don't see the trees, I say.
They see the spaces between.
Now we know the secret of antlers.
And I know a secret about men.
They are watching the spaces.

I watch you two. Beloved men.
Your velvety bodies, sun-darkened and hard with work.
Calm with each other.
Deep in your talk and friendship.
A grove, not for women to enter.
I am laughing.
Whatever I thought beautiful before was a rehearsal for this moment.
Warriors, Lovers, Kings.
Men, beaming with the many petaled, verdant energy,
wounded, various,
rare.
Complex and mysterious as any orchid,
a swath of life, wet, rich, sweet
as where water has just lately
been running.

CATTAILS

I love the desolation of this lake shore in April,
a loneliness not desperate for relief—
the way the moist sand seems to accept for now
the free and careless litter of sticks and reeds.

And last year's cattails stand bleached
and brittle: only the stalks remain,
the loaves of reddish seed now furred away.
What have men together without grief?

The cattail seed loses its brotherhood,
goes down in the mud to die alone.
Men grieve together, and sometimes in spring
a man stands up green and tall from the lake of tears.

BODY PARTS

"Shall it be male or female?
say the cells."
 —Dylan Thomas

you guys find
those Parts yet?

hey! here they are.

MALE GORILLAS

At the doughnut shop
twenty-three silverbacks
are lined up at the bar,
sitting on the stools.
It's morning coffee and trash day.
The waitress has a heavy feeling face,
considerate with carmine lipstick.
She doesn't brown my fries.
I have to stand at the counter
and insist on my order.
I take my cup of coffee to a small
inoffensive table along the wall.
At the counter the male chorus line
is lined up tight.
I look at their almost identical butts;
their buddy hunched shoulders,
the curve of their ancient spines.
They are methodically browsing
in their own territory.
This data goes into that vast
confused library, the female mind.

THE MAN

I like the parts of you
that are not the parts of me,
the furry paws of your knees
and the angular metal of your upper arm.
So often I turn to touch softness
and find taut rope and hard glass.

My body stretches elastic
to meet and hold forum
with the hollow of your back.
I crawl under your thorny face
and find moist refuge.

In such moments
I forget your bones and fingernails.
I surrender to the mud that moves with us,
sinking and rising
in the steam that is our common element.

I NEVER WANTED ONE FOR SEX

Being on the opposite end of the pole,
I can only guess what it's like to have that stick between my legs.
Aware of it all day long as if it were a clogged artery pried
 loose and left to rest hot and sticky inside a bun.
Stiffening at times like an idea that plays with the light of day.
I never wanted one for sex, only to pee out of,
stand up tall with my legs spread in that gunman pose:
every target a bulls-eye, unmissable like hitting yourself in the face.

PRICK

I see you, beneath
my hands, as some
fragile, many limbed
creature—from
deep undersea—underground—from
deep in the shadows.
Pale and
unused to light,
mostly blind when
revealed to sun,
skin soft and tender,
easily broken—
arms and legs all alike and
somehow resembling a
small baby's fingers—not
so good for grasping—
made more for reaching, touching
what eye cannot—ill formed eye, peering
outward.
You most often choose not to be seen—
either burrow into me as if I were
sand or earth or ocean, or hide just
behind me in the
bed we share—the
only habitat where I can understand you.

Tender anemone, shy starfish,
daddy long-legs vibrating till
invisible in a corner
web. Millipede.
Beneath my hands you
grow into some mysterious
creature—
many limbed where sight tells me there is
only
one.

PEEING

for Jhett

At first we believed this
was the last place it could happen.

It took years to understand this.
That meaning is defined in our
most basic processes.

The way we kneel to cup
the world's two most perfect hemispheres,
to support his naked body
as his most recent accomplishment
arches perfect in its mathematics
over the low horizon of our days
and into the bowl.

Each boy has been here,
holding his penis for
the first time with purpose.
This could be the first
of more than 71,000 attempts at cleansing.
I do not know when I first learned
there is no way to remain clean.

Waiting here now, kneeling before dawn,
waiting for him to give it
the one perfunctory shake,
I am sure it was early,
beneath a bare bulb
near the mirrors waiting to swallow us.

NIGHT TOGETHER

for D.B.

This close, but without touching,
your penis inhales, stretches its neck,
arches its back
to align its spine.

This close it lingers and stares,
its one centered eye trained
on its mark, aimed
toward the inner space I make for it.

Never blinking, it sheds
one tear for the sheer joy of being
this close and begins to clear
its heavy throat.

While it hoots and hollers, flexes,
pounds its fists on its chest, it wonders
how long it will
sob, after losing all it has gathered.

This close and silent, grateful
for returning to its old self,
your penis hunkers into its hooded collar,
snaps off the light, and sleeps.

Our First Fight

I passionately stated my belief that Jim Morrison
did not pull out his cock and masturbate on stage in Miami that
he was in a long poetic and romantic
tradition of sexual liberation going back to Blake
and far too intellectual and hugely talented to do anything
like that while Joan
screamed back that she had BEEN THERE
she'd BEEN a go-go girl in the bars when all the hippies
and druggies and pool hustlers and cool beautiful people decided
that he'd done it and furthermore Morrison was FUCKED UP
OF COURSE he'd done it and as a matter of fact he DESERVED
to go to jail while I
screamed back about Freud and Norman O. Brown
and Artaud's Theatre of Cruelty
and Morrison's feigning masturbation as an ironic comment on
the superstar/passive audience quagmire and what
great brave and highly moral standards
he had
until
we both backed off
horrified into separate rooms stunned
by the fact that we were on the verge of possible divorce
over what Jim Morrison
had done with his cock.

A Trim

My husband cut my pubic hair,
Sculpting a woman back into a girl.
Butchered, slaughtered, a prize at the county fair.
My husband cut my pubic hair,
A rabbit caught in a hunter's snare,
A marching marionette giving the baton a twirl.
My husband cut my pubic hair,
Sculpting a woman back into a girl.

Balding

With every spring,
as the west wind snaps flags,
my hair is blown less;
fewer strands remain
to catch the breeze.

Stranger than this is
that any strands are left
after the shearing of genes and seasons,
that the locks I have
still proclaim themselves among
banners in the wind,
above the ground.

My Husband's Beard

Salt and pepper gray, my husband's beard bushes out
in fullness.
Gray swatched asymmetry, the face askew,
at dinner he wipes his beard with the intensity of a cat
licking his whiskers.
Covered with snow when skiing, ice cubes drip off
and cashiers call him Papa Smurf,
or Willie Nelson at Club Med,
or Rabbi in Fiddler on the Roof.
He's identified by his beard.

I love my husband's beard when he kisses me, tickling my
neck, my nipples with silky brushes. The dressing for
sensation as his sweet smelling mouth covers mine.
Soft not scratchy. What a surprise.
This man surprises me in every season.

Late summer surprises of my passion
and if I talk of love: what of plate throwing anger,
winter meanness to this improbable lover.
Eccentricities to drive me insane and allergic to cats.
Yet, he dances divinely and loves extravagantly,
taut body honed by basketball and skiing.
A body of a twenty year old with a beard in the fifties.

I want to express my appreciation
for hair covered maleness
like eating mushrooms or okra:
unexpected textures and tastes.
Describe love between ten year olds,
teenagers disguised by middle age.
I want to shut out images of aging: eyeglasses,
surgeries, illness.
I want to tell you about my husband's beard.
Salt and pepper.
The spice of my life.

SMUGGLIN' BLUES

II
a thousand dancers
wearing turtle shells
behind the right knee

seeds rattle
looseness
in each stomp

multiplicity

V
more men
round the world
wear kilts
 than pants
what's they got
 under the skirt?

for some
the sporran's sheepskin
pouch decorates an older one
hidden,
and woolen clout

genes
identified
 by plaid

IX
the old man has a young son
why so late?
it's my job he says
smuggling sperm
 from the ancestors.

she smells
sea foam
 and lemon
like rain coming.

THE SPERM AND THE EGG

The sperm hate the egg.
They are afraid of it.
An ogress.
They clot the hot
red anteroom,
clinging to the walls.
She is blue and pulsing.
They are small and inadequate
and lose their tails.
Their chlorine milk begins to spoil.
But on the journey
when the shudder swept them
into an excited knot and
expelled them all together,
early sight scattered ahead of them.
They traveled like a shower of comets.
It was as if they were the universe.

The egg puts out her slimy pseudopod
and takes the sperm into the jelly.
The sperm is hysterical.
Now the egg is busy changing shape.
The sperm does not want to
be pulled apart into strings.
"Don't unravel me," it cries.
The egg does not hear it.
Deep inside the sperm
a seething hatred for the egg.
"When I had my tail,
I was free," the sperm cries.
It remembers the ultimate
vast trajectory.
It remembers them all crying,
"To be or not to be!"

A Place of Sense

I want to know my body
as some women know their own:
without romance or pride,
touched by hands that trust themselves
to cup, not crush, an infant's skull.

I want to know my body as a place
where I have always just arrived,
where travels end, or start;
not this weary instinct
sharpened to a sperm-taut edge
for piercing all that it is not,
and every organ but the heart.

I want to love my body
as women do who oil their thighs
and then the legs they taper to,
who pause, bent-kneed, dipped in light,
to hold the curve of instep,
palm pressed to foot's long palm,
pulse calling to calling pulse.

I want to love my body for itself alone,
a wilderness of unknowable truths,
green and deep with storied beasts
too brave, too shy for hunters.

I want to love this body,
this broken land locked dark
but for the fading light
in one amber window
of a dark house
in a dark street
of a city built by women
for the man who drove them out.

FATHERS & SONS

pointing at the moon
lightning traces
his hand

—Ann Newell

It's Hard to Hug a Pregnant Woman

It's hard to hug a pregnant woman in bed.
She is bigger;
every spot is a tender spot.
Between her knees, a pillow to ease her back.
She seems out of reach.

It's hard to sleep next to a pregnant woman.
She asks things like:
If you needed to, could you apply a tourniquet?
Why does our car sound like sharpening knives?
Is it me, or do the crickets sound like they're arguing?

Sleeping on the downstairs couch
is like sleeping in the bow of a ship.
From here the highway sounds like the ocean.
I drift and the waves carry me.

The city on the coast
has houses big as cathedrals,
playgrounds like black prairies.
Angels dressed as crossing guards,
their orange belts radiant,
receive me on the shore,
walk me here and there,
tell me familiar stories
from strange perspectives,
then tuck me back into my boat.

I open my eyes.
My wife stands before me.
"I think she's trying to jog,"
she says, putting my hand on her belly,
taut as a sail cupping the wind.

I feel a pulse, a code,
and send a message in return.
 Rest easy. Land is in sight.
People, some whose voices you know,
walk the shoreline,
welcoming.

J. Kates

MATTHEW

When his wife's belly swelled like a starving child's
he doubled up in their bed and moaned with pain
until she fetched him milk and summoned the doctor
in the middle of the night to calm him down.
And when his son played his first live fish
all along the sunlit bank of the river
he set his beer carefully on a dry stone
and turned seven, leaping and shouting in glee
as the boy wound and wound the small trout to shore.
When his wife left him to experiment with art school
and took a job on the newspaper and a local lover
he wandered bewildered across the length of the country
with his son in his hand, his only companion.
They entered adolescence together like a new town,
fishing for women and girls, fishing for words,
moving (as children who have grown up together will)
farther and farther apart, like a father and son.

FOR ERIN

Small and new, you turn into me
as if you'd crawl inside where nothing hurts.

If I could open this man's body
I'd tuck you under my ribs
and warm you in the infra of my heart.
You whimper, awake, then instantly dream,
and forget the sharp things and cold lights and
hurts the world out here holds.

Forget the isolette that held you
a clear oven for your little loaf.
On your smile you slide back
to where you were always held
and cushioned and fed
and put your hands by your face again
the pose that made your birth take so long.

Maybe if you'd held them that way forever
you'd still be riding in the best ship there is
instead of this cold train
of emergency, test, and therapy.
Crawl into me, small girl.
I'm holding my ribs up like an umbrella.

MY BABY GOING UPSTREAM

This is no crawl, this thing he does on the floor.
 It's a private undulation,
a nameless motion causing friends to say
 whoa, I've never seen *that* before.

He transforms, his eight-month old body becomes
 the curved wood of a rocker bottom swinging facefirst-
 feetfirst.
To begin, his arms push up
 like a weightlifter's at work, barbell head held aloft,
 muscles desiring
 the GO-sound like a tense sprinter
 waiting on the blocks.
When arms lock,
 feet and knees lurch forward to make a hill of his rising bottom.
 Rimmed spine becomes a curving horse-shoe,
 a U-shape upside down.
His unspilled luck is momentum gathered at the top,
 like a sled above sloping snow,
 or a home-made car at Soap Box Derby
 ready to fall toward the fluttering tape.
His body flows, arms lunging like paddles licking at a lake,
 knees-thighs-waist-belly-chest
 all pass like a train going by,
 its conductor calling towns,
riding rollercoaster wheels to Here-We-Go-Wheeee-Look-At-Me.
 Then hand-brakes reach for the free-fall,
 and neck, defiant,
 holds the head from the floor,
 like a bungee cord unsnapped.
His feet point to sky
ready to coil, to begin again
 the tail whip of a homing salmon
or the swimming original seed.

Baby Boy Bath Ritual

1. The mother will ask him—he's 2 and a half—if
 he's ready, "Are you ready for bubbles, Marlowe?"
2. He will say, "Bubbles, Bubbles" when he's ready to go…
3. She will start the bath and test the heat by dipping
 her elbow in the first 2 inches of water…
4. Her silhouette will remind you of a white crane with
 long black feathers, three feet down her back,
5. He will run from room to room, pretending to be chased
 until you get the hint: "can you Play?"
6. If you don't get the hint, he will take something of
 yours—something small, and taunt you into chasing him;
7. He will win this game, because it is made of him
 getting your attention;
8. You will also win because the attention you finally give
 up will feel simple & clear & good like love without the
 Label;
9. He will tire you out so you have to stop, but…
10. It will be in the bathroom, and he will begin to pull
 off his shirt, which will get stuck over his head…
11. She will be dripping bath bubble liquid in the water
 as the depth reaches above six inches. Meanwhile…
12. The toys will magically congregate of their own will
 around the tub…
13. He will tug at his pants, not quite able to get them
 below his diaper; he will tug at your pants saying,
14. "Daddy bath, Daddy bath?" in that lilting questioning
 tone, which tears your heart…

15. He will change your mind about not getting wet at 8 PM
 on a Wednesday night; you begin unbuckling your belt...
16. He will bubble over, giggling as he tugs down your
 jeans, making you stumble,
17. As you step out of your shorts, into the Pooh bath
 bubbles, you will sigh a groan of relief at entering
 his world outside your mind: warm water, white fluff.
18. As you sink down, he will imitate your posture and
 sigh a higher pitched groan of relief, "ahhhh..."
19. Smiling self-consciously at Mom outside the tub,
20. He will say: "Daddy's pee-pee, My pee-pee."

Elizabeth Jacobson

FOURTEEN MONTHS, A MAN WITH DEXTERITY

My boy with his obsidian eyes, a face of berries
Thinking all over the room like a bee trying to get out
 of several closed windows.
Proud man chest, thick piñon legs
A body made of made-to-last clay.
He reaches his hand up under my shorts to grab hold of some
 flesh.
He has been two months without my milk,
And bites into my breast as if it were a nectarine.

Deloris Selinsky

GETTING ANSWERS

My grandson walks the shore,
talking to the crabs and waves,
the pebbles and the seashells.

He's quite fortunate.
None of these have ever
answered me; yet they seem
to give this kid a yes
or no, or any other answer
he has set his mind to hearing.

Ebby Malmgren

THE SHOW MUST GO ON

without a father
I'd not be a daughter

without husband or lover
I'd not be a mother

would not have a son
to father a daughter

to marry and mother
daughters and sons

without sons or fathers
husbands or lovers

the stage would be empty
the story would end

SONS

We've wrestled since
we stood upright—
fathers and sons
in loin cloths or business suits, something
forever burning in back of our eyes.
The sons always win; soon after
the fathers are dead
or almost—thinking it's always Sunday,
their eyes lost in the circus mirrors of memory.

Now
there are only books
for me to learn from, strangers
to emulate. The ground rises up,
begins to cover the sky—suddenly
I'm a child again,
I see my father
joyfully lifting me
high above his head
in one golden sweep of memory.

I lift my son
till he covers the sky.

BRETT'S GAME

Slowly the leaves unpile themselves
until my son appears smiling.

How is it in there? I ask.

Arms outstretched, he falls back
laughing like a cherub in a corduroy hood.

I ask again. He throws a handful of leaves
at my face. They flutter, floating
to the ground like young birds.

Really, I persist, how is it in there?

He lies back, straight and solemn,
side-stroking the leaves over his body,
then wriggles his arms till wholly covered.

Finally he says it's dark with pieces of light
and he can see my face like the man in the moon,
only hairy. Now go away, he says, and don't tell anybody.

BUILDING

for Jhett

Bill and David, familiar
with the bridle and windmills,
have never seen a tool like this before.
They cannot implement a history
of an axle of large wheel
driving such small gears
now locked and cold as hell.

Through the barn's collapse
we watch the sun plow a February sky
feel the wind funneling in
whipping our faces.

A rabbit has spent weeks struggling
dragging straw here from the henhouse
through the woodpile, under the Mustang
over the thin, brown grasses.

This is where the rabbit lies
dreaming of owls and coyotes, nightly
of each shadow as shelter or sacrifice.

Bill says, He's built himself
quite a home in there. My son,
planted deep in a snug hood,
thinks about this. He can almost hear
the rabbits' tiny hammers—
see the need for building.

A Note from Home

To whom it may concern:
RE: Robin's absence from the Fourth grade yesterday

In keeping with the Board of Education's policy that a written excuse must accompany a returning child who has missed time from school, I offer you this. Not an excuse, rather, a celebration. He looked so peaceful sleeping yesterday, when we peeked in on him at 6:30, we decided to let him dream and spend the day at home. The general consensus around here is that childhood bottoms out far too quickly, and while the classroom offers discipline and routine, it's also the grim prophet of occupational malaise: clocks and ciphers and a myriad of "have-to's". So we let him sleep in. That is our prerogative and we did it, and no, there were no sniffles or sneezes in our house yesterday.

Robin decided to spend the day with Mom and the dogs and cats surrounded by his precious totems, his books, tapes, toys, the plethora of research materials he deploys to get a handle on growing up in fin-de-siècle America—an exquisite jumble decipherable only by him.

Yesterday Black Dog went to the vet to get the stitches out of his leg. Running madly while chasing a ball, he had stumbled on some long-forgotten window panes in the tall grass of our meadow, drawing a horrifying fountain of warm blood and a panicky dash across town for sutures. Black Dog spent a long caged night, bandaged and sedated. Yesterday they came out, so Robin had a field trip to see medicine up close and done right. He stood in the vet's examining room calming Black Dog, saying "GOOBOY, GOOBOY," patting down the shivering flanks until each thread was snipped loose. There's the life lesson—that dashing blindly through tall grass can draw blood.

Next, a field trip to the beach. Robin walks far ahead. There is the gathering of pebbles and glass worn so rough it looks ancient. The shells he swears are wampum, and, look Dad, an original arrowhead; the outside air has a soothing, meditative effect on him.

He strolls and meanders and observes firsthand how nature puts herself to bed for the winter, draws silent and reverential where infinite sea and sand collide. This from a boy who loves the *Simpsons* and *X-files* and will absolutely not wear clothing that Michael Jordan has not anointed with his signature. This is his geography, his biology.

Off to visit the library. Browse the shelves for the new R.L. Stine, or perhaps a tract on vampires or sea monsters or dusty walled cities long lost to time. His interests range far afield, dizzyingly random. We can only stand a reasonable distance away, as a crowd will watch a basketed balloon ascend from a summer's meadow.

The next morning, today: business as usual. The clock radio he found at the dump jangles out weather and traffic snarls a half hour early. He arises, ready, rested, and vital, not draggy and catatonic, like some days. His day off has healed some malaise, spiritual torpor or ennui. Whichever, it is his to know, and his to heal. The raw power of a boy busting loose, who glides on the hot wax of his own agenda, thrills us. At 7:20 we feel warm breath on our face, whispering, cajoling, "Get up. Come ON! Time to GO TO SCHOOL." We dimly fathom that the pendulum has once more swung to academia, to his friends, to the teacher who asks how he's feeling today.

You see, Robin isn't really different from us adults. We work hard, we play hard, we must recharge, decompress. It's usually on another's forgiving terms: a boss, a spouse, a client. So we are never really free, even when the day off comes, after we've successfully run the gauntlet and are thrown our bone. That's why Robin stayed home yesterday. Fourth grade is a long sentence for a boy. Playing hooky is what the child in everyone wants, needs. We envy someone who wakes up with no job or debt to pay. When we become so rich that work is obsolete our lives once more resemble children's lives, unfettered by "have to's" and giddy with enchantment.

So, to whom it may concern, this is Robin's excuse for being absent yesterday. Just so you know, for the future, in our household we give time off for good behavior.

DOG SMILES

My son John liked to dress the dog in people clothes
And Pushka, in silent adoration
Endured it all for the love of my son

Pushka, John would say, How 'bout a nice coat?
Over each front leg he'd carefully slide
The sleeves of my brown gabardine raincoat
And fasten the first three buttons
To keep him from walking out of it

A hat'd look good, don't you think?
And over the floppy ears went his father's old gray fedora
Sunglasses, finally, to mask the bright eyes
And the costume was complete

You look very nice, Mr. Riley, John would say
Then he'd wrap his arms round the patient dog
And slip off to sleep on the living room floor
Boy and dog, dog and boy
An island of quiet in the afternoon sun
But from beneath the raincoat
One could just see the long white plume of a tail
Gently thumping against the worn carpet
And a long-nosed dog smile behind dark glasses

SHOEBOX HOUSE

Her father sits down on the living-room floor
and makes her a shoebox house.

"Here is the door," he says, cutting a flap,
"where people go in and out."
She listens as if an ancient story
were being handed down.
"Here is a window, to look at the world," he says.

Soon she has her dolls going in, going out,
eating and sleeping and playing,
and she is absorbed, learning more than she knows—
he watches her, thinking

Lares, whatever gods of the hearth,
you're more capricious than the Thunderer,
though they offered you quieter worship...
Now she pretends that Mother and Father are fighting,
shouts *I'm mean!* from the father,
puts Mother face down on the handerchief rug,
makes weeping sounds.

A door to go in and out, the man is thinking,
Oh child! And feels again in his chest
the wicked language of a slamming door.

QUIET, IT'S TOO QUIET

for Jillana

1.
A neighbor stopped me tonight.
"It's so quiet now," she said.
"Years ago, there were kids
all over the block." Her words
held me. She was right: it's quiet
with you out of the house.
When I work late, there's no one
to worry about—still out,
partying, driving. Silence
follows me upstairs. Your room
is dark, and much too quiet.
It's too quiet at dinner:
your special edge, that rapid-fire
impatience, is missing: a spice
whose absence unmakes the meal.
Too quiet in the den. Even
the bathroom fan is eerily still.

2.
Nothing is quieter than a gull
gliding seaward, except a tern
dreaming on a buoy marker
in the sea's narrow channel.
Nothing is quieter than this
quiet, in which I write to you:
gone from our house. Daughter,
nothing is quieter than this break
in the weather that promises no rain,
low humidity, none of that startling
and clamorous lightning you love—
that lightning you are.

3.
I think of you and I grow quiet,
as I did when you rode in my arms, clung
to my shoulders—I kissed your hair,
the pure beauty of your skull, the bones
of your neck, kissed you and prayed
for you: health, clarity in this life.

4.
Children play and gulls cry,
but it is much too quiet. Years ago,
you knelt with your toys, held
by their secret voices. I watched you
for hours. Silent as a slow breeze,
I knelt in your pool of silence.

Stephen Bankhead

SONNET: THERE ARE NO BASEBALLS

There are no baseballs needing to be thrown,
or movie ratings that I must inquire.
I never have to wait to use the phone,
or take the time to patch a bike's flat tire.
No handprints are upon the windowpane.
Remote controls are easy to locate.
No algebra equations to explain,
or rows of verbs to help him conjugate.
There are no toys awaiting my repair,
or bedroom mess for me to rearrange.
I see no skateboard lurking on the stair,
and find no arcade tokens in my change.
 My life has suddenly become so clear,
 I feel it has begun to disappear.

THE MAP OF A CATCHER

Three-year old Zach lays out,
in proper order and flat on the floor,
the catcher's equipment from my 30+ team
and proclaims
Look, a map of a catcher!

He is in love with this gear, worn with
playmodeling devotion for Randy, my
catcher, his hero (*Homerun, Randy, yerrout!*).
He looks like a house compressed onto
two miniature stilts
with face mask & helmet rafter-sized about his head
shin guards rising to the flooding basement of his chest
chest protector like a pontoon for floating away.

When Zach says *Bonk me here. See? Doesn't hurt!*
I wonder how he'll learn about a catcher's real contour,
unaware of Randy's lump-filled geography
marked by wild pitches taken off unprotected thighs
baserunners' elbows in his bare face
scoopbruises in the knees where the endoscope looked in
& gnarled, mangled hands.

If he never catches, my little receiver will be loved unconditionally,
he has nothing to prove in this old pitcher's unstitched heart.
If he wants to catch, he'll catch, but only if
...and now this is like a prayer...
if wisdom centers his face like an I-beam, if strength shows
in the sinew & muscle of his foundation, if courage energizes
his persistent veins like oakroots lifting sidewalks of skin.

MARATHON

for Josh

Twenty thousand zealots
stream over Verrazano Narrows
to the messianic beat
of rubber soles on asphalt.

Moving on to Bedford Street
arms, shoulders, torsos glisten
underneath November's sun
stolen from July.

I stand my corner searching
for blue shorts, white shirt.

Forward, down, up, back, my head
moves like a conveyor belt.

Blue and white are everywhere.
I'll never find him, never,
when a wet cheek touches mine
and I hear the words

"Hey Ma," before he disappears
into a battalion of limbs
drawn like steel needles,
to a distant pole.

THIS MAN

This man—I shook him when he cried
I pressed him in the quilt
I pushed him in the tub
I rattled him in the carriage, and I screamed

This man—I threw him to the pillow
and shoved him on the bed
bloodied him with my hand, my flying hand
my let-go fist
my ignorant fingers making telltale welts

This man, who couldn't find enough
milk in my breast, cried in the heat,
arched his back, twisted tense,
shit green, and banged his head

This man I choked with puree
pressing his cheeks
to force open his mouth
pushing the spoon
down his twisting tongue
holding him in the chair with my elbow, my arm

This man—I taunted and berated, begged and cajoled
I beat his bottom, pulled his curls,
smacked his back, his shoulders, hands, legs, feet,
and (oh) his face; pushed him to the wall, threw him down,
demanded sleep. This man, whom I force-fed beets and beans
and poems

who, when he first walked, back and forth, ran
back and forth in a terrified glee,
smeared shit on the door, broke the phonograph,
froze before speech,
and then he recited a line of Keats

152

This man—rocked the crib, twisted his hair,
said *you* instead of *I*
encircling the room, and I beat him again
This man, I wanted him perfect and wanted him fixed
and wanted him gone. This beautiful man
who turned and turned and lost his way
and met bullies in the street and came home hurt,
his hat in the bushes, his papers torn, his face wet
I sat him on the sink, and he talked gibberish
while I shook him and screamed
thinking to shake words out, trying to shake words in
calling him names

This man, I mocked his drawings
and yelled at his fears of socks and fans
I ridiculed his reading about a crippled boy
I called him "queer"
and repeated *Go out to play*
like the other boys, mow the lawn like the Garner boys

I said, *You never make friends or listen to the teacher or*
speak to me. Why don't you walk straight, listen to me
This man, who walked on his toes
and I took him to doctors and made him do lifts,
stand straight, walk lines,
me yelling *FEET FEET* day after day
and at night I called, *STOP SHAKING THE BED*

This man: When he dreamed in school and banged the keys
and couldn't swing or ride his bike
I yelled and hit
When the neighborhood boys made him eat shit
I hit and yelled
When he spilled milk or refused beans or kicked or
sneezed or wet his bed, I hit and yelled

This man who hid behind so many panes of glass
that our conversations were one way shouting in wind
glass and wind

This man who became an ox and struck me down
who left my house and dropped my name
who slammed my door and screamed in rage,
You hit me with chains

This man, whom I couldn't train and couldn't feed and
couldn't teach and couldn't talk with and couldn't
accept, I held him, yes, I loved this man

I loved this man
who has just allowed me into his house
who has just now walked me up to the crib
and has watched me lift his baby up,

he has watched me take the baby in my arms
and hold him and dance and hug and croon

This man smiles as I hold his son
That is my song, song of sons,
my newborn song

PNEUMONIA

Stars through the windshield glinted,
shrunken, delirious as the eyes
of sharks. I heard mother's
heart (my head
cradled in her elbow's
crook) chant *faster*, and father
tramped down the pedal
when his lane was clear. Later,

lungs drowning in my chest, I sucked
at oxygen fresh from a tank. Thin
voices leaked in, trembling
the tent's wrinkled,
transparent skin. My mother's
face was a pale smear on the air,
her jacket a haggard ghost. "Doctor,"

father said. (I remembered his brown
palms, coarser than emery cloth
on my back, circling slowly
to draw insomnia from my blood;
the fat scar barnacled on
his thumb would whisper
along my ribs: *A man becomes
all that he's lost*.) He rasped,
"Doctor...will he die?" I let

go: the hiss of piped air drowned
his answer. And when I came to,
they were gone. Bones of cold light
flickered above my bed; hot urine
eeled between my legs and froze;
fins, in my fever's depths, ripped
through swelling tides of sleep:

the blackness swallowed its stars.

155

ROSES

Whenever I try to dissolve
that man in hatred
a picture of him
with his arms running blood
comes up
how he came home from work
on a night in late May
and walked past us
with two quart containers of ale
bubbling foam in his fists
and our mother said
look Brad old Piney's protecting his roses
and pushed us to hold up our shirts
and show him our stomachs
the thorn gouges
dark glyphs of blood
the lesson we learned from old Piney
who dragged from his brush pile
the harshest dead rose canes
and lashed them to our fence
and our father put down his ale
and kicked open the door
and ran up the yard like a man
who never ran
and tore at the barricade
of inch-thick rose canes
'til his hands looked like chomping dog jaws
cupping blood
and his yellow nylon shirt
was a butcher's shirt
and he threw the canes
so they landed on Piney's porch
and he walked past us into the kitchen

and got his ale
and escaped from us into his bedroom
where it was cooler
and stunk less of bleach and frying
and crying kids
and we still had cream and pink and yellow roses
to carry to school in glass milk bottles
for the Virgin
and to bury our faces in
dizzy from that sweetness

Hans Jorg Stahlschmidt

GERMAN CHILDHOOD

Whenever he screamed in his dreams
my mother would throw herself
on him, on his tormented body turning
and turning in white sheets

We all threw ourselves on him
my sisters and I to stop the snow from
falling, snow from Stalingrad falling for
twenty years, falling onto our chairs, our beds
onto my red fire truck with the silver bell

I walked carefully in the morning
with bare feet, not to disturb the large
sleeping body behind the door.

REFLEX-TIONS

daddy i know u never touched me
 (at least not like that)

 but u don't need ta touch someone
 in order ta make them feel uncomfortable
 in their own home

daddy those times when we used ta lay tagether
 in yr bed in our underwears
 (like spoons one cuppin another)

 they still with me

those nights u'd come home alcohol on yr breath
how yr elastic watchband would catch the hairs on my head
n pull them out
 one
 by
 one
 even as u tried ta pull away

 (how u'd always apologize for bein so clumsy)

it's why i still flinch whenever yr hand comes near
why i stopped drinkin three years ago

 (well that n the rape
 n the fact that i started sayin i "needed" a drink
 instead of sayin i "wanted" one)

it's why i always sober now
n why i want ta know exactly what's goin on
at all times
wherever i am
whoever i'm with

daddy i want ta come ta u with open arms
 but these fists r cramped
 they won't uncurl

Kaylock Sellers

..

BROTHER

baby
baby brother
I how I do not
envy you the only
male growing up in
a house of women sisters
mother grand mother & &
an ark of female furies so I
apologize know you you got
singe d more than twice
once but you fffuried
back as because one
everyone must
find their
peace.

DAD

Big hands hoisting me plunk
onto a bar next to big plates
bigfaces bigvoices bigfingers
poking me *eat—eat*! Big

fists pounding my mother bent
covering her face whimpering
cornered by the stove.

That night we run away run
from New Jersey and her job
to Lowell and her mother.

Only once more: knock! knock!
on the kitchen door back of
our tenement end of the alley
Irene opens reels back shrieking
blood flooding her face—
curses and a manshape big.

I grab the knife beside my plate
run lunge stab stumble my
head explodes I bounce on the floor
more curses big feet clumping
fading gone.

Your father! She aims it through
blood and broken teeth straight
into the center of my head
tattooing a rose of hatred there
scarlet white and pure as bone.

But you don't go at your father
with a knife, whatever the
blessing, and forget it.

A TASTE OF MY FATHER

Find me afterward in the rain,
naked. I have tears in my eyes,
bruises on my face and hands;
I dreamt my way out of childhood
again, and still did not win.

No walk in a summer storm
will wash the smell of him away.
No nightmare will absolve me
from this likeness in the mirror.
His skin, freckled and pale,

is my skin, now that I am forty,
approaching the age he was
when he first touched me
and did not smile, but moaned.

He comes into the room at night
to sleep in my body, heavy
in the bed, thick with liquor,
the taste of cigarettes in his mouth.

A razor of light from the doorway
cuts across my tangled sheets.
The house is bloody with silence.

FAMILIARITY

I no longer pretend I don't take
after my father. Drawing water
into the tub, I am reminded: how
each morning he wakes and stands

at the edge of the pond we built
for his birthday one summer
adding water from an orange hose.
He is in my blood and blood,

they say, is thicker than water.
Yet each echoes the other, familiar and
imperfect. Does not the ear, coiled
like a shell, mistake the rush of blood

for the ocean's roar? My father
is absorbed with koi, whereas I pursue
coitus. Men's cocks dart in the wet
of my mouth. I leave them like fish

out of water: all gills, gasping,
mute. Well, not always so soundless;
who cares what the neighbors think?
My father and I have no common ground

to stand upon, so all we talk
about is water. For years I longed
to be a world-famous marine
biologist, learned to swim, kept sea

horses in a ten-gallon tank. My sister
rode in Pony Club; sibling rivalry?
Or was it my first sign
of inversion, watching all those male

sea horses giving birth to hundreds of babies?
Those fathers showed no compunction
at eating any of their children who strayed
too near. My father is always threatening

to gift me one of his fish. I can now
tell him I already have a carp in the bathtub,
or rather, a kaposi sarcoma I found
below my left knee, on the back of my calf,

while leaning forward over the water and
pouring out bubble bath from the Plaza Athenae,
where a man from Denmark took me last
Friday after we danced together at a club.

He had meant to stay at the Plaza Hotel, but his
travel agent had not known the difference.
He had not himself recognized the mistake
and, having come this far, it was too late

to turn back. I stared at the sore
on my leg, the world wanting to slide
away into nothingness; but I, too, felt an
inexorable tug. I stepped into the tub.

It was too late to turn back, as if the water
were not simply drawn, but somehow broken
again. I could not hold my head under water until
I felt cradled in the womb once more, protected,

safe, then rise up from the foam
like Botticelli's Venus, reborn, blemish-free.
I was too big to crawl back into the womb,
just as I was too large to fit comfortably

in the tub, some part always sticking out
into the cold air: arm, leg, shoulder. Should I slit
my wrist with the sharp edge of a broken half-shell?
What was I waiting for? It always comes back

to blood. Acknowledging those familiar
relationships we always want to deny. I stretch
my hand beneath the water to touch
the sore. I can tell my father now

that water is involved.

Charles Fishman

FATHERS ARE NOT STONES

Fathers are not stones, though their voices
may be gravel, their lips granite-white,
nor are they stars set in the black night
to guide us—not stars, not distant suns,
though their light pales with age.

Father, if not stone, why is the path
to your heart so rocky, such a cold climb
to the top? if not star, why do you burn
in sunlight?

Stones are not fathers, nor are sons stars
to warm them when their wrists ache with cold
and their old hips break, when the heat rushes
out of them like a wing in flames.

If not star, a small fire, a saving ledge.
A hand-hold will heal me. If not stone,
then yield your softness. Father, warm me
so I have life to give.

MYTHS

dawn —

temple bell

hum

—*Thomas Fitzsimmons*

"The soul of man is larger than the sky,
Deeper than ocean, or the abysmal dark
Of the unfathomed center."
 -Hartley Coleridge

ICARUS

It was his idea, this flying thing.
We collected feathers at night, stuffing
our pockets with mourning dove down. By day,
we'd weave and glue them with the wax
I stole after we'd shooed the bees away.

Oh, how it felt, finally, to blow off Crete
leaving a labyrinth of deadends:
my clumsiness with figures, father's calm
impatience, cool logic, interminable devising.
The sea wind touched my face like balm.

He thought I'd tag along as usual,
in the wake of his careful scheme
bound by the string connecting father and son,
invisible thread I tried for years to untie.
I ached to be a good-for-something on my own.

I didn't know I'd get drunk with the heat,
flying high, too much a son to return.
Poor Daedelus, his mouth an O below,
his hands outstretched to catch the rain
of wax. He still doesn't know.

My wings fell, yes—I saw him hover
over the tiny splash—but by then I'd been
swallowed into love's eye, the light I've come to see
as home, drowning in the yes, this swirling
white-hot where night will never find me.

And now when my father wakes
each morning, his bones still sore
from his one-time flight, his confidence undone
because the master plan fell through,
he rises to a light he never knew, his son.

ICARUS, MANHATTAN

Across this fortressed isle
I move at a jerky pace
elbows at odds with my body

crawl step after step
one hundred flights up
slip between blades

of enormous fans silent
of spinning atop the shafts
of abandoned lifts

I hide for a while behind
cylinders of metallic water
net pigeons defeather

purple loosestrife lures bees
I melt their wax
my skin catches fire

Dizzy I cling to the roof
at last kick off
flap dented wings falling

rise on currents of steam
and smoke over Hoboken
then over oceans I soar

When updrafts peter out
I too will drop in the sea
but now I've learned to swim

ELVIS AND THE BIRDHOUSES

"Sophomore year [Elvis]. . . took wood shopOne of the projects. . . was to
 bring an article from home that needed to be repaired." —Peter Guralnick,
 Last Train to Memphis: The Rise of Elvis Presley
"*I Hear a Sweet Voice Calling*"—Gospel Recording by Elvis Presley

One morning, in soiled glitter,
he heard, above his retching, a song—
pure, clean like grass sheathed in dew—
a bird, unwavering . . .
and he listened.

After sleeping off his violent confusions,
he awoke to build birdhouses—
of fine pine with a clean wood smell,
flat-hewn in his otherwise swirling world.
It was difficult—coordinating hand and eye,
in contrast to faking harmony
in surging night environs.

He trembled,
but he completed one,
and another,
climbing up trees himself to place them.

And birds came. Not like strange women who adulated
some ghost of himself. The birds came to sing,
as he once had—songs sweet,
painfully pristine.

He was always awake before dawn now,
hating the hounding of his attendants
to return to the slick sleaze of performance.
And so he decided to die.

Watching his own funeral while
lovingly applying a roof,
he dreamed of symphonies,
and felt pangs for the weeping women whose King was dead.
But he was no prophet, just a carpenter.
He had succumbed to the simple rhythms of nail and wood.

Somewhere, in the North, he
fills his houses with winter seed
for the birds of the field.
Far beyond his waxen dead image,
in a cabin he has built himself on wild acres,
he remembers being a boy, impoverished,
and revels now, poor in spirit,
as he blesses his bird-graced lands.

TASK

He stands in the shower, a serious angel.
Finger and thumb at the bridge of his nose,
water steaming down the beautiful back
no one but God loves day in and day out.
He thinks: Something is missing, something that,
if it were present, would render my presence
unnecessary. The soap smells of cassis and he glides it
over the sore points on his trapezius
where powerful wings were pinioned once.
Life now is a more commonplace fall from grace:
eat food but don't taste it; play music
but don't hear it; indulge the self-centered
and call it commerce.... It's not a savior the world needs
but a savoring spirit, a way to relish what's already
begun to vanish. The shower is warm and moist
and he just wants to stay put for a small eternity,
let someone else wrestle with the evanescent.
But he has his orders, which, once issued, can't be revoked:
Recover the taken-for-granted. That's why he hovers
above a child's gouache, a summer dress, the grass-fragrant
symmetry of playing fields. Why he's drawn to running water,
a birthday wish, the crackled glaze of celadon.
Why he exalts in the power a silent moment wields,
and the number two, and the sweet word *yes.*
Open his notebook and you'll find disconsolate souls
who shuffle through the maze of their second childhood
whispering his name. You'll find pennies on the sidewalk
even the poor ignore. Skylights are there and scaffolds,
and desires in the dead of night concealed from the day,
and the ebb and flow that only happens
after certain secrets have been revealed ... It's his mission
to protect all this from the tyranny of indifference.
When he wipes steam from the mirror, a face appears
and his task continues. Pierced ear, cheekbone,

a line near the mouth when he smiles
some take for adorable, some for diabolical—
a thoroughly human face he accepts as his own,
that he carries through the streets like a photograph,
wanting to say to whoever will listen: Have you seen
this missing person? Do you recognize this individual?
Take your time, look closely—and I can go home.

Hans Jorg Stahlschmidt

MEETING THE BUDDHA NEAR BANGALORE

It is only stone he kisses leaning across
the giant toes, kissing the cold towering rock
as softly as no flesh ever before, his hands pressing
into the marks left by endless monsoon rains.

The Buddha doesn't blink, his eyes eternally
veiled behind lids of stone, knowing about
love and time and sorrow without looking,
but a small blueish pulse travels slowly
through the rock upwards.

The old man cries like a child at the colossal feet
and the god cries without sound at the foot of
the mountain and when the man turns, adjusting his
white shawl over his naked shoulder, he carefully
licks his lips with the tip of his tongue as to taste
that instant again when he was not himself.

THE CARPENTER

Someone nailed her; and someone
would have to marry her, who
yet maintained she was a virgin—

mercy!—what with her belly bulging
like barrel staves. Still, she was
a cutie: her bright eyes shining

like varnished mahogany, her skin
golden as honey oak. Finally, I spoke
plainly to her, as befits a man

of my trade, saying, "Sweetie,
you have snapped a chalk line
down the center of my heart,

cut through it cleanly; won't you
finish your work and be my wife?"
Which was a hard row from the get-go,

what with taxes and the necessary
commuting to construction sites;
plus there were the predictable

sniggers and jokes about another
man's chisel in my toolbox
But we managed. We survived.

And when the child arrived I
raised him as if he were my own,
instructed him in the many things

a carpenter should know: first
and last, good wood from bad;
how there's a time to sand

and a time to caulk; the wisdom
of working *with* the grain;
that every job must stop. Sad

to say, his aptitude was minimal,
his interest in the family business
nil. Instead, he read, brooded,

roamed the wilderness alone——
a sensitive boy, and bright, but
looking for god-knows-what? I don't.

Frankly, it worried the wife a while.
Frankly, it worried me too. Though
isn't that just the way of the young,

needing to figure it out on their own,
anything beating the old man's shoes?
Times were changing fast, it's true:

timber was scarcer, money tight. So
why not a future in fasting and prayer?
No chip off this block, the kid could be right.

AUTOBIOGRAPHY

It was the rock.
The cold gray stoniness of it
there in the earth at the edge
of the field I'd planted and hoed
while my younger brother lounged
on the hillside watching his sheep.

It was the way red striations
divided the rock from bottom to top
like lightning gashing the sky.
And thin angles whetted sharper
than envy by God's choosing
one man over another.

The heft of the rock drew my hand
like a magnet. Rough granite
edges cut into my palm.
I tightened my grip.
The hard power of rock
flowed through me. I felt
in my body what it could do.

Odd how my brother's
blood trickled to match
the ragged stripe in the stone.

After losing the farm I
wandered Eastward, a marked
man, estranged from the earth.

Then I married and fathered the future.

ANOTHER SON

Why does he call me Ishmael now
that I've been kicked out
of the family tent. First they wanted me
and then, got fed up caring. He took
me up the mountain and lucky
the angel and ram appeared
in the nick of time. I was favoured then
and they called me Isaac, and she laughed
the whole Sabbath through and half the week.
But when their spirits fell
and they got tired
and wouldn't let me out with the shepherds
and their girls, they sent me off
to Hagar's tent and told me she would be my mother now.
I'm Isaac, I told the woman, Sarah's son.
"For me, you're Ishmael," she replied.

Ishmael, that's what he calls me
and in his aging fits, who knows,
he'll throw us both out into the desert
while he talks to himself about another son,
a perfect Isaac subservient to his dreams.

WILLIAM TELL'S SON SPEAKS

I do wish Dad
would give up on this:
but he stands there still, too far away,
one eye pulled into a paternal squint
sighting along that damned shaft
while I wait, absurd, still life
with an apple in my hair.

At this point in my storybooks
someone always gallops to the rescue
maybe it'll be the Lone Ranger
riding on the wave of his overture
to point out with his Colt .45
how my father might reconsider
this practice of targeting me.
But no hooves arrive.

"Have faith," Father tells me,
"I never miss."
"Miss once, and I'll be never,"
I mutter, but he doesn't hear,
one ear tuned to his Swiss watchmaker God,
the other to the wavering wind.

So I'm Isaac and he's willing to bet me
on one more test of his belief.
Or he's Isaac Newton, set to kill
the apple of gravity with the arrow
of his thought. Me, I'm just a body at rest.

What does he need me for?
He could skewer this fruit on a fence post
with just as fine a shot. A post that would also
look better wearing a miss
than my smooth boy's brow would.
But it's too late to tell him anything.
His fingers are just releasing the string,
while his lips hiss: "This is for you,
son!"

How We Got the Hole in Our Roof.

Titanium man had been struggling out
of the magma for days, and now he was
like a steel-hardened drill, tunneling
through the earth, up and up, all to
breach Superman's lair in our basement.
Of course, Superman wanted to save us
from the behemothic assault. After all,
we let him stay with us once in a while,
when things got rough—and maybe he
the man of alloyed steel could wrest
control from this source of his non-
corroding, harder edge.

But I said, No. I said, Don't even try.
You're no unswallowed son of Cronus
like Zeus who fought ten years
to strike his Titan father down
with a bolt of thunder—
and this while his father
looked the other way.

(I didn't want to see the Titans' brawl
destroy our fragile peace.)

I said, You're a blameless orphan, not
self-made. No taint of patricide
lingers. You defend the weak and meek;
you're not the god who said, "Let them eat
raw meat," and then withheld our fire.

When Superman turned my way
(I think he'd finally heard
my cautionary words), I said,
if you really wanted to save us all,
you'd fly away. He did.

Alone in the House

Alone in the house
I walk through the sun-
filled rooms singing
but somebody follows me
with a heavy hand on my shoulder

To whom did I make this secret
promise to turn down
my life's flame

The maiden marries the prince
but at the banquet
one seat remains empty

In the mountains
the wounded deer with the silver antlers
stands still under the trees

Nobody knows what was said
in those dark basements long ago
but a huge dead man turns in the ground
bending his stiff fingers into fists

WHY WOMEN OPEN THE DOOR

When the dark stranger comes to our door
with a few tarnished daisies and an empty bird
cage, he says, *I've got winter in my pocket,*
a few old answers in my shoes. I can do
nothing. His boots are muddy, he reeks of
swamp, but that's not quite enough. *I've been*
adding it all up, he says, *and it looks*
bleak. We step out on the porch.
My last bird, he says, *died of nostalgia.*
We sit in a rusty chair. He crouches on a
splintered step and pulls out his wallet.
Want to see some pieces of a heart?
We consider brewing coffee with warm
milk. *I'm restless,* he says, *always heading*
north, south, east. We'd like to
clean his fingernails, give him a new
flannel shirt. He smiles. *You're not my*
ideal. We wipe our hands under our
knees. *It's expensive,* he says, *especially*
in this depression, but I've known you
from the beginning. We let him in.
I'll just stay a minute, he says. We run
a hot bath. *Well, okay,* he says,
but I wash my hands of it. We draw
the shades and take the phone off the hook.

FATHER'S CURSE

My wife wants me
to fill her belly with seeds.
I fear the fruit that grows there
and the knowledge it brings.

As she rounds, I wait for the beast
that comes to test my faith.
Do I have the divine arrogance
to create another in my likeness?

She will push forth the innocent demon
into my arms
and sigh relief
like an ocean subsiding.
The imp will come screaming,
and I will push it away,
screaming.

I will conceal myself in meaningless tasks,
odd jobs—a farmer harvesting deep into the night,
a mechanic mothering endless carburetors, a judge
beating his gavel angrily,
a drowsy bus driver signaling left,
turning onto another highway at night, traveling
north, always north.

THE KITCHEN WITCH

Your mother stays with us after the miscarriage.
She flies out from her Louisiana kitchen to fix you,
makes you dress and wear lipstick, sends me
after holy water. She mixes it with her urine and
your blood and dumps it into a bucket of water.
She mops the floor, praying rosaries—
Saint Francis Saint Thomas Saint Mary Saint Ann.
She moves through the house, scrubbing
the baseboards, washing our floors as though
she could scrape away the dirt in layers,
as though she could scrape me from you.

This morning, I warm my hands over coffee as
black as the pot your mother watches. She stirs
out of the pot of alligator gumbo, a Bayou.
I am afraid that if I look into the broth
ten more Louisiana Catholics will jump out,
tie a scarf around my waist, and pull me back
and forth to give me rhythm. You always said
I didn't have rhythm. At our wedding, you
teased me onto the dance floor and led me
in circles around the room. My foot caught
on your dress. The music stopped.

I feel that rhythm now as you rock in your
great grandmother's chair and stare at the glass
angels your mother suspended from the ceiling.
The dog in your lap licks the inside of your wrist.
I try to make you eat, but you will only take
cautious sips of the iced tea I offer you.
Your lipstick makes the glass look kissed.
I reach over the back of your chair to touch you—
your hair, your heart, your breast, your neck—
but your skin is as cool as those ice angels.
Your mother mops around us, making an island
of your rocking chair, and I dissolve into nothing
but one hand cupping, dry-rubbing a breast.

PLUTO TO PERSEPHONE

I know what it is you
want from me
but you see
I cannot give it
I am hell
and hell
is a nice place to visit
but when you want to leave
you want to leave

when you speak to me
you converse with darkness
hold my hand
old bones rattle
when you kiss me
imagine kissing
the skull of a saint
mouldering in a cave
large balloon of spirit
flown imagine taste of white bone
reposed in darkness

sweet bursts of pomegranate
on your tongue
seeds bitter
with promises they have made

the longer you wait for me
the more the world suffers

ELEGIES

"Where there is sorrow
there is holy ground."
-Oscar Wilde

in my heart's orchard
please be the pear tree that blooms
as if forever
 —Alvaro Cardona-Hine

Box Set

to fix in a box neatly what remains of your
voice and what was yet to come from
you, tom, seems an odd wish given the
detritus that sat so long in the claw-footed
bathtub in the kitchen of the two room
pad on macdougal street where we hung
out before and during your brief heyday:
the guitar pics like hairs clustered at the
drain the rotisserie league line-ups like
wet rags stuck to the sides the lyrics sent
from oregon a crumpled ball committed
to memory the signed photo of van the
man your bushy head against his
shoulder and the torn knicks playoff tickets
a gift to you on the occasion of your first
cd though it was on record that you first
taught me about music and the need to
stay young when i left the city and
returned home to the more sensible
clutter of family and job made ready in a
quick chord change for the start of middle
age ending my free nights with you
earlier and earlier until the cancer
choked you like the unseemly clog that
stops the needle in the vinyl's groove
and kept you from finishing what i long
for now in a box set to square you forever
with the songs you still had to give

PULLING PETER BACK

Since you died I've tried to pull you back
through the dove-tailed joints in the
white pine toolbox you made for me,
hoping to squeeze you through the cracks.

And when I cut a board
I measure twice, pulling the rule
out to a birdsmouth mark. I expect to see you
standing there to double-check.

I can wrench the rusty nails from a plank
of spruce, hear them squeak in the
claws of my hammer, but you won't come loose.
You never suffered chaos gladly, and stacked
the two-by-twelves in perfect level piles.

But I'm stubborn too. I yank at the plumb bob,
hoping to feel you at the other end, my rule
poised to measure the length of your fall.
I tug at the chalk-line, snap the blue string
across the roof to mark the shingles' path.
If only you'd appear from that familiar dust.

I look for your face in the grain
of the butternut burls you sawed
neatly into cutting boards, in the ice
that clicks in a glass of bourbon.

I can't stop pulling the blade on the knife
I gave you for your birthday—till I look down
and see the red on my palm.

THE 1937 DODGE

Left by my father's Uncle Wesley
to his nephews,
the shining car sat
undriven, in a closed garage
for twenty-five years
while the three brothers
fought over his estate.

It rested amidst the poverty
of their lives, shored up
on concrete blocks
among rusting oil cans, jars of nails
the bolted double door.

Fine machine, I would hear
the uncles say when they spoke
of it, *mint condition, a beauty,*
as though speaking
of some virgin of youth
longed for and never possessed.

I like to think of that car, in its dark home,
gears, brakes, engine intact,
cold as their antagonism
which turned to utter silence.

A temple to the family stubbornness,
it perched on its base
of heavy blocks
the color and weight of spite,
and never moved from its throne,
remained while Esther,
Eleanor, Dorothy, and Bess
married, grandmother died,
the house crumbled,
vines snaked up around,
looters smashed windows, lamps,
hacked up the furniture
while the brothers could not
make their fortunes or settle
their dispute. And the great
Dodge shone, colossal
in its tomb.

Dressing My Father

My father was a natty dresser so choosing a tie for him was tricky.
It couldn't be too wide, too narrow, too jazzy, too plain.
It had to say something, but in his voice.
Not for him the clamor of "power ties" nor
the bland safety of the retired.

The shirt—white, narrow button collar—had to be sharp, crisp,
not stiff. The handkerchief for the jacket pocket was key:
an accent most men these days would miss.

It was funny dressing him, like dressing a bride,
so much care for clothes worn once then put away.
It was peculiar enough, never having shopped for men's clothes,
assuming strangers would assume I was shopping for some husband,
and those who knew me that I was getting into drag.

Getting, instead, into my father's humor:
Imagining running into someone on the Avenue, them asking,
"I hear you're burying your father?"

Me replying, "Have to. Dead, you know."

My father was a natty dresser. We couldn't let him down.
But there was no sense in dressing Pop too formally.
We brought his favorite sports jacket, his new charcoal trousers.
Called for flowers, chose a coffin, handsome, stately yet somewhat
less dear than Tutankhamun's.

They laid him out looking "natural" enough,
his hair swept back in some generic style.
We combed it back down before company came,
gently crowning his forehead with his silver waves.

LEUKEMIA

Even in pain,

his heart murmur howling,
his backbone insistent,
he said nothing.

At seventy-four he still outshore me,
a steady pace all day, six weeks before death.
Sheep no longer struggled with him,

as if they knew he would never cut them,
as if they knew death was eating him inside
like maggots on a foundered ram.

Laughing, glucose and poison in his veins,
flesh drum taut on his wrist bones
mottled like a tanned and weathered hide,

said: *Sheep are the most disease ridden animals.*
 And we are second.

STRICKEN

because of J.R.W.

How does it happen:
the stream-strong man
all bowed leg and forward march
brought to his knees in the garden
fingers wound through the dirt
guts threaded with a fine thin flame
delicate as the lash
that darkens the eye.

OLD MEN AND WIVES

I saw my father cry
for the first time
when my mother died
I stood beside his hospital bed
his head in the hollow of my shoulder
 He had cooked though he hated to cook
 shopped though he hated to shop
 He had dressed her and washed her,
 asked her friend for advice:
 which purse, which shoes, then escorted her
 vacant-eyed and stooped, to the banquet,
 as if she were his golden girl
and while he wept he said, "I'm glad she went first."
That was thirty years ago

 Last summer
Chuck trusted no one else
to lift Maria—wheelchair to toilet—
Rarely left the house for eighteen months
not even to the garden
 And every afternoon
a cocktail party—martinis and canapes
on a tray—they toasted
as they had for fifty years
He kissed her bald head, called her "my sweet"
rose from sleep three times each night
to turn her in the bed
lay down to wait again beside her

Paternal Borders

Every year we leave New Mexico—
mesas, sage brush, elk. Cross borders,
enter your land
squared with wheat, containing covey of quail,
speckled with lakes, for mallard and teal to glide upon.
That place where my brother knows all about deer—
velvet antlers, bone, tracks in the snow.
Every year we go back to him, dying father,
hoping he will find a kinder hole to crawl into;
leave the state,
leave the earth, metamorphic.
There is a beast named Alzheimers
which devours his dignity,
slovenly licks its fingers.
This time when I said good-bye, I meant it.
Before, his lips fell. This time that veering mouth
pulled north.
Eyes focused, holy, immense.
Tear ducts wizened as two parched ponds.

I told him that some people wait
for his money. Let them have it.
I told him many wrongs were done.
We can rain forgiveness, wash your muddy guilt away.
I reminded him that he practiced meditation
to realize God, and he is waiting
just behind your eyelids.
I said, let go, and you could fall through the sun,
galaxies,
the black hole.
You could move through eternal grace.

We are born with these skins.
We die from the inside out, shedding them off.
Only the dove remains.

SUMMIT

In memory of Scott J. Gogulski

I walked up your mountain today,
Sun-blinded, heart eroded
Feet stepping over anthills,
Taking the sting and spitting it out again,
Dreaming of snakes on the road.

I walked up your mountain today
Feet pressing dry earth.
Yucca, cholla, chewed dog biscuits,
Coyote excrement and lollipop wrappers—
Cherry-red Indian boy aiming to shoot.

I walked up your mountain today
Feet crying tears into the desert ash,
Eyes hidden, forehead of an alien
Or aged Georgia O'Keefe
Scavenging the prairie for signs of life.

I walked up your mountain today,
Thought of making my death at your summit.
My bones lying there with yours,
Black crows carrying away my flesh
Leaving me stripped of vanity.

I walked up your mountain today,
Sat next to the circle of rock
Fingering through the dirt,
I searched for the white fragments
That once held your limbs.

I walked up your mountain today
Sun-blinded, heart eroded.
I swallowed a single piece of your bone
Prayed for your power, your presence—
An antidote to my venom.

GROWING UP A BLOCK AWAY FROM JOHN MCCRAE

John McCrae wrote "In Flanders Fields," the poem that came to exemplify the sacrifices of men who died fighting in World War I, and also made the poppy the symbol of such losses. His house in Guelph, Ontario, is now a museum.

Winter is withering through the dried grass
beside the river where you walked every day

Nov. 13 and snow stays on the ground
Your poem locked like a gear into the season

At John McCrae Public School we memorized your lines
and marched to this site Remembrance Day,

little boots in broken step, without the faintest idea
of what you meant: "We lived, felt dawn, saw sunset glow

loved and were loved. And now we lie in Flanders fields."
Where farmers still plow up bones from 1915.

Each year after the pumpkins grin and the first
snow stays, aging campaigners plant plastic poppies

like annual wounds on the chest of the public.
This is what your images become:

parodies of the bloody blossoms over the graves
of farmers' sons gone to die for abstract ideas.

How far men will go to die. And now two Omegas
stuffed with dried flowers flank

the bronze book where verdant and locked to time
your words march on ... in Flanders fields.

How Do You Want To Die?

Air Force One, night flight from
Miami to Washington, Nov. 18, 1963

I'd like to die quickly, say, in a plane crash. But if
they're going to get me, they're going to get me,
even in church. Remember the time we were attending
Mass in Hyannis Port and the whole pew behind us
was filled with reporters? I turned and asked them,
"Did you ever stop to think that if anyone took
a shot at me, they might get one of you guys first?"

Now, Jackie loves that bubbletop because it keeps
her hair from getting windblown. But there's no way
around it. They put me in a bubbletop and I can't
get to the people. I want them to feel I am
the President of the United States, *their*
President of the United States. I belong to *them*
—they don't belong to me. You can't stop a guy,
can you? If someone tried with a high-powered rifle
and a telescopic sight during a downtown parade,
there would be so much noise and confetti that
nobody would even be able to point and say,

"It came from that window." If this is the way
life is, if this is the way it's going to end,
this is the way it's going to end. God,
I hate to go to Texas. I hate to go,
I just hate like hell to go. I have
a terrible feeling about going. I wish
this was a week from today, wish
we had this over with. We're going
into real nut country.

LAST TIME I REMEMBER BOB WELL

Bob in his Hawaiian shirt, red rayon, screaming yellow flowers,
Louis' party, thirty people and counting, spilling up the sagging stairs,
in the bedrooms amid the coats, down the cellar by the beer keg
into the yard and the shouts of neighbors,
cooling off from parlour dancing.
Bob standing apart, in the early days of the plague.

> Chubby still, back then, though the shirt is really Jeff's.
> It never used to fit him. Bob does look forward, at last,
> he says, to getting thin.

You greet him, go to kiss him as you would any friend.
Choose to kiss him, to kiss him on the cheek
despite the flare in his eyes, the buzzer in your head.
He drops his beer.

Eyes big, a wave of hops froths around him.
He blushes deep in his big red beard
hands aflutter.

You toss napkins on the floor to blot it, as if he were just being clumsy,
tease him despite or because—the terror in his eyes.

> "Keep it up, Bob,
> we're gonna cut off your supply!"

He apologizes that he keeps doing that, spilling things
as if it matters to this beat-up floor,
as if Louis won't invite him to another party.

> Faith whispers:
>> "He did the same thing with me.
>> I kissed him hello and he dropped the whole glass."

His eyes ask:
 "What are you doing?
 Don't you know the danger?"

You tell him you can't resist him in his outrageous shirt
that you want it and you want it now.

He looks wary as you hand him another beer.
His eyes ask:
 "You know you're in jeopardy.
 Why do you come near?"

Some stay away.
They mill near the cheese, backs to him, turning now and then
to smile and retreat.
They don't know what to say to a dying young man
in his big red beard and his screaming flowered shirt,
dying as long as some of us have known him
dying faster now—we can see it—at Louis' party.
Dying as we all die, alone.
Dying also in headlines, in Congressional committees,
in pulpits, in back rooms from New York to San Francisco,
everywhere in between, in Haiti and Zaire, the places researchers
have yet to go.

You kiss him on the cheek. Kiss him goodbye.
This time he holds onto his beer.
You leave him at the party
still saying goodbye.

AIR

In memoriam: Steve Chambers 1940-1995

Marcy called, said I should
go soon to say goodbye to Steve
or I would miss the chance.
So, that morning I entered
his small clean apartment
and immediately noticed the air had grown thin,
yet easier to breathe, as if what
he must take in and out of his
congested lungs had changed itself for him.
I found him lying in bed, just a head
above the covers, tended to by a
long-time friend, his best, he told me,
in better days.

He recognized me, I feared
he might not, and my presence
in the room made him anxious.
He asked to sit up, so I helped him
swing his withered legs over the side
of the bed, and then held him, with
one hand against his chest.
He was working hard, as I had ten years earlier
to birth my daughter, though what he
was birthing seemed to be rising up
from his feet to pass through
the rattle in his chest, and come out
perhaps, at the top of his head
through that unseen orifice
Buddhists can spot with their third eye.

We sat this way together for a while,
he growing heavier against my hand
while I listened to his rapid breathing.

He wanted to lie down again
against the pillows, but did not want anything
else we could offer: water, ice, food.
His only request—to be left alone.
I remembered that state in labor
my midwife called transition: spaced-out,
untouchable, floating, the air in the room
shimmering with anticipation.

We left him in his bed and sat at his
dining room table, where I sat
so many times in the months before—
listening to his stories of Fire Island,
his restaurant in Soho, the
Korean War, all against the back drop
of British pop music—and no one knows
this, but sometimes I danced in his living room,
his Salome minus veils, enticing
one dying man, who even when well,
had no interest in women's bodies.
His Lily of the Valley, his Rose of Sharon,
I would dance to keep death at bay;
the cut flowers on his dining room table
dropping their petals when my feet
came down hard, the water in the vase
vibrating, his head nodding to the rhythm,
all our eyes shining.

I got the call at 8:30 that night.
Marcy washed and dressed his body.
His eyes, although closed, seeming
to watch her every move.
I put on the stereo and danced
in my own living room, dropping tears
each time my feet came down hard,
beneath them the thin air turning.

STRIPPER AT THE FUNERAL

No one thought to read "To an Athlete
Dying Young," while tearful orations
crackled the speakers in the overflow room,
though homely poems of youthful philosophy
plucked from Mark's midnight scrawlings
gave voice to the dead athlete himself.
I strained to concentrate on Mark's words
in a church game room where I'd been ushered
with later arrivals and found myself lost
among two epochs of boys I'd taught.

A morning's teaching called to sudden halt,
still dusted in chalk, I'd fled into an October
noon trailing clouds of blackboard quotes
and now I faced a suited line of linebackers
all twenty-five, like Mark was—multiplying
their high-school selves to the third power,
wider shoulders, stronger jaws, their eyes,
narrowed by years of midterms, scrimmages,
love agonies. The tallest, directly in my line
of sight, wrote memorably of his sojourn in Hell
for my Creative Writing class and now journeyed
famously as "Chazz," the headlining stripper
in jack-off spas, masturbating on stage
for the men who'd pay to watch. I refused
to meet his gaze, across the rows of younger
boys, the ones Mark had coached, the ones
who'd just sat in the same plastic desks
as Mark and Chazz had, enduring my pre-funeral
lesson, skinny kids of fifteen, their beardless
faces all screwed up from trying not to cry,
their manly stances betrayed by twitching knees.

But Chazz kept staring, as if to strip
me of my chalky cloak of normality—
for years we'd traded glances in the gym
and all the bars, and I knew that he knew that
I knew what none of ex-classmates might ever know.
I'd never seen his jerk-off act—the huge fact
of his body embarrassed me—he was supposed
to remain a schoolboy in plastic, chaste.
Standing there, cornered by my students
of fifteen and twenty-five lined up among
ping-pong tables and croquet mallets, I bore
the surest fear that Chazz would strip right there—
shimmy hard and naked while Mark's ex-history teacher
eulogized Mark's grasp of ancient civilizations
and modern civility.

 I gripped the pool table
behind me, then altered the angle of my gaze,
over to a jumbled line of third-grade boys,
tiny critters in stiff suits—Mark's own students—
who'd long before given up all resistance to tears.
Their strong, laughing new teacher died of weak heart
and now, one little boy surrendered to his loss,
fainting and falling full-force forward.
A gasping circle of grown-ups surrounded the boy
while Chazz hustled across the linoleum void
to cradle Mark's student in his arms, stripping
off his jacket to make a pillow for the boy's head.
Chazz unbuttoned the kid's dress shirt, exposing
the baby-flesh chest, and leaned in, his jeweled ear
meeting every beat of the boy's broken heart.

THE VOLLEYBALL PLAYER

for Doug Goeble, murdered March 20, 1991

1.
His picture in the paper, blond and brave,
with Cecilia, who would have been his wife,
seems lifeless in a way he never was. His
father, the Colonel, stands rigid, unbending,
no display of the despair that must have shaken,
privately, that military frame, and with Cecilia
on his arm. Three pictures, full color, blond
on blue, police academy photo on a later page,
a huge parade of fellow officers showing
ritual support, flying flags: ceremony, pomp, public
display of common desperation as he begins
the slow return to dust. This is not enough.

2.
On Wednesday nights we played a game,
and he would always play to win, his body
flying through the air, arm cocked back to
slam the ball. Cold fury, fusion that could light
the gym. His whole life focused on the point,
eight-foot net, red lines precisely thirty feet away:
a moment in the air or diving to the floor to dig
the ball and save the game. Twenty-six years old,
he smashed his body on hard wood, sprained his wrist,
twisted his foot and, listened to the sage advice
of generations of military men. He played with pain
as if, in each volley, something more than just a game
wormed into his core, forced the tension to explode,
a sharp directed shot, the ball blasting near the line.

CHUCO PACHUCO CARNAL

for José Moreno

In the "colegio" where the establishment
sends our best Chicanos is where we met.
What was there for me to teach you—
against all odds you educated yourself
and stood taller than all of the guards
who kept watch your soul would not escape.

Today, your sister wrote me:
...lo siento mucho a informale
que José pasó a la otra vida 16 meses atrás
pero antes se reconsilió con Dios.

Did God offer a better deal?
It was what you always wanted
to be
to be free
to be on the other side.
Curioso, the manila folder with your name,
containing tus cartas y poesías
inside the file cabinet
kept rising above the others like magic
or tratabas de dicer me algo.
Me pongo loco trying to figure out
what it is you are telling me.

I remember how con tu sonrisa
you gently corrected me, the teacher—
pointed out *"Hispanics are not in prison!*
Raza, they lock up Raza," you said.
We laughed: I learned a lesson.

Rereading your cartas, anger overwhelms me
knowing the establishment is still crazy
locking up our Raza.
I want to tear down all the walls
melt down all the bars and chains
that for too many years incarcerates, locks away
genuine souls like yourself.

Your soul escapes … taking a deep breath
my chest feels heavy around my soul.

Miriam Sagan

MORE THAN ONE BUDDHA

Yesterday, on Canyon Road
I took a turn into a courtyard
The gallery that had been there was gone
More than one Buddha adorned the lawn
Ten or twenty, thirty maybe
Cast from the same mold
Classic cross-legged, eyes cast down
Offerings in the lap of every one
Chrysanthemums, or asters, Mexican sunflowers
Attested that autumn was coming
Strings of prayer flags
Swayed above the garden
The cafe was closed
Those Buddhas grouped in family arrangements
Remind me, husband, that you are dead
And gone off somewhere without us
Still, all day long
It pleases me to remember
What pleased you—
Umbrellas, teacups, shoes, rain

CLAIMING KIN

Maybe he didn't know where he was going that night, or why. Only that it had to be done. Our kind, I know, do this simple thing. But later, if asked, my father would tell us about the fog that night. How the air was thick with ghosts pressed cheek to cheek in the dark, tangled like Indian rubber men. Somewhere in that night his brother lay dead, one man's legacy of a refiner's fire.

How he steered behind a diesel all the way to Channelview on a road flashing with fog lights, ghosts passing nameless, falling into darkness. Maybe he pressed buttons on the radio, puffed on his cigar. Opened the windows to let wind blow through his thoughts.

But his brain would not stop singing, a dirge for a brother so still and silent on a county slab farther up that road. Waiting to be shrouded in a flag, mourned, then let go at last. Set free.

Wind, even fire, can't be that free.

It all stops with the fog. He does not tell us how he walked into the building where the human ceremony took place. Entered a lit room in the night to recognize a face. Different from his own, but close enough to make him understand how a part of him was gone.

Passed away, beyond knowing again.

MY FATHER'S BREAKFAST

After his first heart attack my father
gave up bacon, butter, cream and cheese.
Mornings he ate dry toast, black coffee
and a boiled egg because eggs,
he knew, were good for the heart.

I'd watch him slice the egg
dead center with his steak knife,
hold the two halves carefully
while orange life spilled into his bowl.
He cleaned the white meat
from the shell like a surgeon who knows
each gesture counts. He performed this ritual
alone, his eyes alert and bargaining.

Each day he shrank, the egg
grew larger in his delicate hands
until he was nearly hidden
behind the opaque world whose secrets
he would devour.

It's just an egg, I said, in case
the egg wouldn't keep him here,
but he smiled such sorrow at me, his only
child, that I began to understand
the fragile mystery of skin like a shell
holding, hiding
blood, thoughts, laughter and a thousand
terrors, unborn children.

Break us and love pours out,
or tiny prayers with their fingers crossed,
or hunger when our only father
has finally disappeared.

ELEGÍA A MI PADRE

Because of your birth in the manger of San José,
when streetcars went around barefooted
and uranium had the innocence of moss,
you were generous as a smile or bread that is distributed,
and goodness fell on your heart like a drop of water.

Because your childhood awakened suddenly next to dew
in a mountain that echoed town and firefly,
you undoubtedly inherited the immortal gifts of the land,
a certain bent or skill for the confidences of the landscape.

Because your youth knew humble tasks
and you conducted trains at dawn like a shepherd of fire,
and loved the peasant girls
and hope was your comrade,
you received the medal awarded only to the humble,
a medal made of hard work, broken wages and sorrow.

Because, if sometime, running into the false friend,
he wounded your early morning, your forsaken nobility,
a will deeper than a snare brought
your corner of shadows the infinite condition of the free,
and you kindled honor on your forehead for the rest of your life.

Because your fathers, trained in the liberal rose,
planted books and children, and perfumed their actions
with patience and perseverance not exempt from heroism,
you embraced the griefs of men, their works like statues
and the small miracle of letters that sing.

Because you traveled through the maps of my blood, and placed
your seed at the core of my mother, preparing
the drama that I am, the underground fury that invades me,
desire, thirst, poetry, alabasters of the soul,
electric creatures born when I was conceived,
I thank you from the solitude that shapes me,
and place my thanks in this basket of words I send you now.

Because one day that resembled the hair of an angel,
you entered the cave of the orchid, and reviewing
the leaves of your country, you plunged into the overwhelming
and musical madness of birds,
the sacred harmonies of the forest became your allies,
and the spirit of its invisible dominions
impregnated your being.

Because seated in the shade of a venerable old age,
before a sunset peopled with murmurs you wrote a book,
and in that book sponsored by memory
you sketched friends, locomotives, dreams,
literature decorates you and dawn is beside you.

Because your ideas, free of dogmas and carriages,
stemmed from the rage of the people, from its joys,
and you paid homage to the red guardians of the planet,
you were the gold of the past, future sincerity,
a rebel carrying dusk on his shoulders.

Because you founded a new home, new children, histories
threaded by a remembrance turning into spikenard,
and, evoking the clear males of myth
the sons of the children of your sons accompanied,
like custodian clouds the proximity of your mystery,
I bless and concoct the moon of that image
that is your face turned to water, abandoned calcium and mist.

I came from afar to listen to your martyrdom.
In a valley pecked by the birds of Poe, in winter,
you coughed and coughed as if they were hammering
at a wooden box there, in the corners of the night.
Crossing chambers of fear, led
by the distant destruction of my mother, this cough
was calling with its knuckles on your chest, oh my Chekov,
reminding you of the rendezvous with unending rest,
the joys of oxygen and the consecration of springtime.
And the insistence of that cough calling for you was such,

that one early morning you opened the door to it forever,
and became a small box, fine dust of enigmas,
and, turned into ash, we deposited you in the sea
like a loving plankton nourished by origins.

(Because, being of the soil, of rice and linnets,
hunter of deer, specialist in rivers,
you grew old far from your thrones of shadow
something—I don't know in what shape—of that which you evoked
—pebble, sky, shade, oxcart at dawn—
heard the drizzle of your mortal remains falling
on the green rug of the sky's mirror.)

Thus, dissolved in the totality of nothingness,
you turned universe, bell of a thousand eyes,
cup of abyss, lime newly born,
a droplet of hearing beyond silence,
and within it, your minute leviathan of tenderness.
Immortal joy! The winds of the beaches
bring me your human symphony wrapped in salt.
But, dedicated to joining the sands of being,
or traveling with the atoms that carry life,
perhaps you cannot understand the glory that instructs you,
oh my changeable dead, phosphoric, profound father.
So here I tell you with the passion of the drowned,
touching a snail of tears and clay:
Your grave is a slender cathedral of crystal,
your winding sheet a suit of foam and stars,
you have as mausoleum the beauty of the world,
for epitaph the arc that waves carve
and for worm a reign of germinal forces.
Since then the sea, that gallery of beginnings,
envelops me, I sense it nearer and more terrible,
because in its immense gong all the dead are throbbing
and in it your soul floats like a micoscopic bread.

CONTRIBUTORS & ACKNOWLEDGEMENTS

Jackson Ahrens lives in Los Angeles with his wife and daughters. His work is widely published in magazines, journals, and anthologies across the country. Raised in a house with five sisters (no brothers) and a father whose life was consumed by steel presses, understanding the male experience has been and continues to be a life-long issue.

Phil Austin is a novelist and theatre critic who lives on Nantucket island with his wife Ursula, son Robin, and alarming numbers of tamed animals. He has written of Tutankhamun, astronauts, angels, glacial drift, and is pleasantly surprised, each morning, that the earth is still merrily spinning on its axis.

John Azrak has had a short story in a recently published anthology, *Bless Me, Father* (Penguin), and has been a finalist in short story contests sponsored by the literary magazines *Northeast Corridor* and *Apalachee Quarterly*. His stories have appeared in *West Branch* (Bucknell), *Another Chicago Magazine, The Artful Dodge, The Santa Barbara Review, The Santa Clara Review,* and *Fine Madness,* among others. He is currently the chairperson of a secondary school English department in New York.

Stephen Bankhead is currently a small business owner in Watsonville, CA, and a columnist for its local newspaper, the *Register-Pajaronian*. He tries to cover a variety of subjects in his columns, particularly the culture and history of the Cherokees, of whom he is a tribal member.

Mary Barrett writes in Berkeley, CA. Her poetry has been published in a variety of literary magazines and has won Bay Area awards. "One Summer Dusk" is a childhood reminiscence from upstate New York.

Ahimsa Timoteo Bodhrán was born in 1974 on El Día de la Madre in the South Bronx. He currently lives in Oakland, Califas, Aztl án, Turtle Island, and is working on his first book *Yerbabuena/Mala yerba; All My Roots Need Rain: Mixed Blood poems and prose.*

John Briggs, a native of Connecticut, is a poet and sculptor who migrated to Vancouver, BC after living in Boston for twenty years. His work has appeared in *Christopher Street, Antigonish Review, Windsor Review, White Wall Review, Slant, Faultline,* and *Hawaii Pacific Review,* as well as other Canadian and American periodicals.

Christophe Brunski lives on the New Jersey coast, where he writes in English and occasionally in French. He would currently say that writing is like being below the surface of a frozen lake and trying desperately to smash a hole in the ice before drowning, but he is confident that this hole is soon to be made. He tries to taste at once the frenzy and the softness of life, and has multiple novels nearing completion.

J.B. Bryan lives with his wife and daughter in the North Valley, on the edge of Albuquerque, NM. He is a writer and painter, as well as a free-lance graphic designer and the publisher of La Alameda Press. His poem, *How Can I Follow My Beautiful Dreams*? is from a forthcoming book by the same title.

Paul Bufis has been published in small press publications and literary magazines for the past sixteen years including *Southern Poetry Review, River Styx, Blue Unicorn, Permafrost, Rhino,* and *Visions,* among others. He received Special Commendation and publication by the Chester H. Jones Foundation. Several of his poems are included in the anthology *¡Saludos! Poems of New Mexico* (Pennywhistle Press). He is a self-employed contractor/tradesman/consultant in Santa Fe, NM.

Alvaro Cardona-Hine was born in Costa Rica and has published 13 books of poetry, prose, and translation. He has received an NEA grant and a Bush Foundation Fellowship. He makes his living as a painter and also composes music. "in my heart's orchard" is addressed to his father.

Alfredo Cardona Peña was a poet who lived in Mexico City. He was the author of 20 books of poetry, criticsm, and tales of a fantastic nature. "Elegía a Mi Padre" was translated into English by his brother, Alvaro Cordona-Hine, and first published in *Dos Elegias/Two Elegies* (Red Hill Press), Fairfax, CA in 1977.

Thomas Centolella was born and raised in upstate New York, where his poetry won awards at Syracuse University and the State University of New York at Buffalo. He was a Stegner Fellow at Stanford University and has taught at U.C. Berkeley, at the College of Marin, and in the California Poets in the Schools Program. Centolella has been a resident of northern California for many years; he lives in San Francisco. "Task" from *Terra Firma* © 1990, and "As It Was In the Beginning" from *Lights & Mysteries* © 1995, by Thomas Centolella, reprinted by permission of Copper Canyon Press, Port Townsend, WA.

Ronald Chalmers was born in 1935 in New York City. He graduated from Columbia University in 1958 and immediately entered the Marine corps, retiring in 1982 as a Lieutenant Colonel after a varied career that included combat duty in Vietnam. He and his wife, Merijane, moved to Santa Fe, NM in 1993. He has one published book of poetry, *Questions from the Shadows* (San Diego Poets Press, La Jolla, CA 1993).

Lorraine Lener Ciancio is a freelance writer living in Taos, NM. Her non-fiction has appeared in national magazines and newspapers; her poetry in *Written with a Spoon, A Poet's Cookbook* (Sherman Asher Publishing, 1995). She is current editor of *Muse News,* a newsletter of The Society of the Muse of the Southwest (S.O.M.O.S.) and is at work on a novel, *Snow.*

Vivina Ciolli has published in *Long Island Quarterly, Negative Capability,* and *The Maryland Poetry Review,* and has received fellowships to Virginia Center for the Creative Arts, Ragdale, and Villa Montalvo, among others. Her chapbook *Bitter Larder* won the 1994 New Spirit Press Chapbook Competition.

Kirby Congdon has had work published in two dozen anthologies; three professional composers have set 21 of his pieces to music. His background is New England, Columbia University, New York City publishing circles, and Key West, Florida. "Daredevil," first published in his collection *Juggernaut,* has been extensively anthologized.

Geraldine Connolly is the author of two poetry collections, *The Red Room* and *Food for the Winter.* She has received two N.E.A. Creative Writing Fellowships and the Carolyn Kizer Award of Poetry Northwest. Her work has appeared recently in *Poetry, The Plum Review, The Gettysburg Review,* and *Chelsea.* She teaches at the Writers Center in Bethesda, MD and serves as executive editor of the literary quarterly *Poet Lore.*

David Cooper won an Academy of American Poets Prize. His work has appeared or is forthcoming in *The Literary Review, Passages North,* and *Mudfish,* among others. "Hunt At Langley" is adapted from E. Howard Hunt's *Give Us This Day* (Arlington House, 1973) and from David Atlee Phillips, *The Night Watch* (Atheneum, 1977), respectively, as quoted in Mark Lane's *Plausible Denial* (Thunders Mouth Press, 1991). "How Do You Want to Die?" is a composite of President John F. Kennedy's private remarks to Florida Senator George Smathers, Peace Corps Deputy Director Bill Haddad, and White House aide Ken O'Donnell as quoted in Ralph G. Martin's *A Hero For Our Time* (Macmillan, 1983) and appears in *Synaesthetic 4,* Spring/Summer 1997.

Sheila Cowing has been published in literary reviews all over the country. She has also written two natural history books for children and teaches workshops to all levels of writers. "Sliver" first appeared under a different name in the *New Laurel Review.* "Tidewater Specialties" first appeared in *Mid-American Review.*

Brian Daldorph is the editor of *Coal City Review.* He teaches at the University of Kansas, Lawrence. His book, *The Holocaust and Hiroshima: Poems,* is forthcoming from Mid-America Press.

Julia M. Deisler lives in Santa Fe, NM, where she writes, teaches, edits, and otherwise occupies herself. She is an infrequent contributor of poetry to journals and anthologies.

Delia Desmond is 21, originally of Berkeley, CA. Since graduating from high school she has lived in Ohio and New Mexico. Presently she is living in Jamaica Plain, MA, and working as the assistant Theater Arts teacher at the Blackstone Elementary School.

Catherine Doty was born and raised in South Paterson, NJ. She received an M.F.A. in Poetry from the University of Iowa. Her poems have been published in *Hanging Loose, rara avis, Mudfish, Louisiana Literature, Steelhead,* and other journals. She is the recipient of an Academy of American Poets Prize, and Fellowships from the New Jersey State Council on the Arts and the New York Foundation for the Arts. She has been teaching poetry in the schools since 1976, and lives in Staten Island, NY, with her husband, jazz drummer Fred Stoll, and their sons, Henry and Will.

Paula Farkas is a writer and artist living in Berkeley, CA. Her work is known and appreciated many places, including the Bay area and her home town of Buffalo, NY. In addition to giving performances of her own poetry, she is coordinator for a popular reading series, and the author of a poetry chapbook, *Figment,* (1990).

Nancy Fay was lured away from gainful employment for the job of editing and marketing at Sherman Asher Publishing. She co-edited *Written with a Spoon, A Poet's Cookbook* (Sherman Asher Publishing, 1995).

Charles Fishman, until his retirement this year, was director of the Visiting Writers Program at SUNY Farmingdale. His most recent books include *An Aztec Memory* (Anabiosis Press, 1997), *The Firewalkers* (Avisson Press, 1996), and *Blood to Remember: American Poets on the Holocaust* (Texas Tech, 1991). *The Death Mazurka* (Texas Tech, 1989) was nominated for the Pulitzer Prize in poetry in 1990. His poems, translations, and reviews have appeared in more than 300 periodicals. "The Boys Have Guns" first appeared in *The Georgia Review.* "Cape Hatteras: 1939" and "Fathers Are Not Stones" are reprinted from *The Firewalkers.* "In This Poem I Am Ten Years Old" and "Red Lights" first appeared in *The Asheville Poetry Review.*

Thomas Fitzsimmons was formerly with the *New Republic* (Washington, D.C.) and feature writer with *The Asahi Daily News* (Tokyo). He is editor of the book series, *Asian Poetry in Translation: Japan* (University of Hawaii Press). His most recent books are *Water Ground Stone* and an anthology, *The New Poetry of Japan.* A Fellow of the National Endowment for the Arts (in Poetry, Belles Lettres, and Translation), he is also extensively published in a number of periodicals.

Al Gabor lives in Evanston, IL with his wife and two daughters. Besides poetry, he also writes children's books drawn from his experiences as a stay-at-home dad. His work has appeared in *Cream City Review, Puerto del Sol, Ascent, ACM,* and other journals.

John Gilgun is the author of *Everything That Has Been Shall Be Again: The Reincarnation Fables of John Gilgun, Music I Never Dreamed Of, From the Inside Out, The Dooley Poems,* and *Your Buddy Misses You.* He teaches English at Missouri Western College in Saint Joseph, MO. "Work" appeared in *Voices: New Poems of Life and Experience*, Issue IV, 1993; "Rifle Rack" appeared in *5AM*, Issue 6, 1993.

Art Goodtimes is a performance poet, writer, politician, arts advocate, teacher, fungophile, and eco-activist. He was poetry editor of *Earth First! Journal* from 1982 to 1991 and founded the Talking Gourds Poetry Festival. He has published several chapbooks since 1977, his most recent being *¡Que Linda!*(No Fat Mama & A.C.Dick Press, Norwood, 1995). "Seeing Bear" was first published in *Wild Earth,* Spring 1993.

H. Palmer Hall teaches writing and directs the library at St. Mary's University in San Antonio, TX. He is the author of *From the Periphery: poems and essays* (1995), and editor of *A Measured Response* (1993) and *The Librarian in the University* (1991). His poems and essays have appeared in various literary magazines. He is the director and senior editor of Pecan Grove Press.

Frank Hart grew up near Washington, D.C., attended Brown University, and has lived in Denver, CO for 23 years, where he currently works for an office equipment company. His work has appeared recently in *Treasure House, Suffusion, Lucid Stone,* and *Echoes,* and is upcoming in *Fuel, Nerve Bundles,* and *Atom Mind,* among others.

Nancy Peters Hastings is the author of a collection of poems, *A Quiet I Carry with Me.* Her poetry has appeared in *Poetry, Commonweal,* and *Prairie Schooner,* among others. She has twice received the Leonard Randolph Small Press Award for *Whole*

Notes, a small literary magazine she founded in 1984. "Father to Son" originally appeared in *Negative Capability*.

Christine Hemp lives and writes in Taos, NM on the historic Hobby Horse Ranch. In 1996 she was the first poet-in-residence at Voyageurs National Park in Minnesota. "Icarus" appeared in *Graven Images: A Journal of Culture, Law and the Sacred*. "Pulling Peter Back" appeared in *The Boston Review* and was anthologized in *Looking for Your Name* (Orchard Press).

William J. Higginson is a poet and translator. His most recent titles are: *Haiku World* and *The Haiku Seasons* (Kodansha International). "this spring rain" is from *Ten Years' Collected Haiku*.

Judyth Hill is a writer, teacher, stand-up poet, and arts administrator. Her most recent books are *A Presence of Angels* and *Men Need Space* (Sherman Asher Publishing). "Where Water Has Been Recently" is from *Men Need Space*.

Shel Horowitz, author of *The Penny-Pinching Hedonist* and three other nonfiction books, has published poetry in many literary journals and anthologies. More of his poems are at http://www.frugalfun.com

Phyllis Hotch writes in Taos, NM. Her poetry has appeared in *The Threepenny Review, The Women's Review of Books*, and *Ad Hoc Monadnock*, as well as a collection, *A Little Book of Lies* (Blinking Yellow Books, 1993).

Joseph Hutchison is the author of three previous full-length collections of poems, including *Bed of Coals* (University of Colorado Press,1995) and *House of Mirrors* (James Andrews & Co., Inc.,1992). He has also published five chapbooks, including the 1982 Colorado Governor's Award volume *Shadow-Light*, as well as individual poems in *American Poetry Review, The Nation, Ohio Review*, and several anthologies. He lives in Indian Hills, just west of Denver, and makes his living as a writer. "Internal Combustion" and "Pneumonia" appeared in *House of Mirrors*.

Elizabeth Jacobson has an M.F.A. from Columbia University and has taught at CUNY in Manhattan and Santa Fe Community College and, currently, a poetry workshop at the Center for Contemporary Arts Warehouse in Santa Fe. Her poems have appeared in *Alaska Quarterly Review, Blue Mesa Review, Flyway*, other literary journals, and *Written with a Spoon, A Poet's Cookbook* (Sherman Asher Publishing, 1995). She lives in Cerrillos, NM with her family.

Michael L. Johnson is a professor of English at the University of Kansas. His two most recent books are *Violence and Grace: Poems about the American West* (Cottonwood Press, 1993) and *New Westers: The West in Contemporary American Culture* (University Press of Kansas, 1996). He is currently working on a collection of essays about growing up in the Midwest.

Lawrence Jones lives with a Madonna and has two marvelous daughters, Jocelyn and Emily. He works with persons who have chronic mental illness. His poetry has appeared in a chapbook by the Des Moines National Poetry Festival, and in

Buffalo Bones, Expressions, Loonfeather, Poetry Motel, and *Cityview Magazine*. "Snapshots" was first published in *Loonfeather*, Volume 15, Number 2 Fall/Winter 1994.

J. Kates is a poet and literary translator in Fitzwilliam, NH. "Matthew" first appeared in *Nantucket Review* #17 in 1980.

Troxey Kemper, a longtime New Mexico resident of Tucumcari, Santa Fe, and Albuquerque, is a retired newspaper reporter and copy editor (at the *Albuquerque Journal*) who writes poetry and fiction. He also lived in Oklahoma, Texas, Missouri, Colorado, Nevada, and Oregon and now lives in California. He is 82.

Roger Kirschbaum has had poetry published in the *Midwest Quarterly's* special issue on the Contemporary Poets of the Great Plains, as well as the journals *College English, Poets On, Green Fuse, Plainsongs,* and *Bouillabaisse*. In 1994, Li-Young Lee chose one of his poems as a winner in an annual contest sponsored by Triton College (published in *Ariel*). He is currently an Adjunct Instructor of English at Highland Community College in Highland, KS, and a freelance writer for the St. Joseph News-Press, St. Joseph, MO.

David Laurents is the editor of T*he Badboy Book of Erotic Poetry, Wanderlust: Homoerotic Tales of Travel,* and *Southern Comfort*, all published by Badboy Books. He lives in Manhattan. "Romance" was first published in *Steam Magazine*, Spring 1995.

Richard Lehnert has lived in New Mexico for 15 years and has written poetry for 30 years. He has been an American male for as long as he can remember. His poem "An Illustrated History of the Civil War," published in the Spring/Summer 1996 issue of the *Nebraska Review,* was recently nominated for a Pushcart Prize.

Natalie Lobe writes both poetry and short stories. Her poems have been published in *The Evening Sun, Welter, The George Washington University Literary Review* and *Passager*. She is a retired urban planner and active realtor.

Eric Lochridge, a poet from Rapid City, SD, published a chapbook titled *Blood That Burns the Flesh* in 1995. He is a copy editor and music writer for the *Rapid City Journal*.

Joan Logghe is a poet and writing workshop leader from Ghost Ranch (Abiuiu NM) to Hollyhock (Cortes Island, B.C.). In 1991 she won a National Endowmment for the Arts grant for poetry. Recent books include *Twenty Years in Bed with the Same Man* (La Alameda Press, 1995), *What Makes a Woman Beautiful* (Pennywhistle, 1993) and *Catch Our Breath:Writing from the Heart of AIDS* (Mariposa Printing & Publishing, 1996). She lives in La Puebla NM with her husband and three children in a solar-heated house they built themselves. "Theory of Tears" appeared in *What Makes a Woman Beautiful.*

Anne MacNaughton is a teacher, visual artist, and poet living in Taos NM. She is director of the Taos Poetry Circus and the World Poetry Bout Association. Her work has been collected in T*he Best Poetry of 1989, Rag and Bone Shop of the Heart, New Mexico Poetry Renaissance,* and *The Best of Libido (1987)* among others. The poems "II," "V," and "IX" are from a nine poem series in her chapbook *Smugglin' Blues.*

Ebby Malmgren is a potter and writer who divides her time between Annapolis, MD, and Taos, NM. She combines her interest in clay and words in a workshop "Clay as a First Language." Her work has appeared in *Written with a Spoon, A Poet's Cookbook* (Sherman Asher Publishing), *The Plum Review, Potato Eyes, Passager, Antietam Review,* and other magazines.

Seymour Mayne is the author, editor, or translator of some thirty-five books and monographs. His collection *Name* (1975) won the J.I. Segal Prize, and *Killing Time* (1992), was awarded the Jewish Book Committee Prize. A selection of his biblical poems, *The Song of Moses* (1995), was published in both electronic (Internet) and print editions. *Jerusalem: An Anthology of Jewish Canadian Poetry* (1996), which he co-edited, appeared in celebration of the 3000th anniversary of the establishment of the city by King David and was awarded the Jewish Book Committee Prize for Poetry for 1997. "Another Son" is from *Children of Abel, 1986.*

Maggie McKirgan lives in the woods with her two cats and a sizeable population of birds, squirrels, deer, and wild turkeys. Recently retired, she spends her time gardening among the rocks, wild roses, and poison ivy; reading the books she always meant to get to; and writing. She has been published in *Her Children Speak, Experiments in Flight, Poet Tree,* and the *Mountain State Sierran.*

Rosemary McLaughlin has been awarded New Jersey State Council on the Arts Fellowships (in poetry and playwriting) and published in *Written with a Spoon, A Poet's Cookbook* (Sherman Asher Publishing, 1995), *LongShot, The Journal of NJ Poets, South Trenton Review,* and *Cielo Azul.* She teaches theatre at Drew University and poetry as an Artist-in-Education throughout the state. Producing Director of the Win Atkins Theatre project, she lives in Hoboken with poet Laurie Jean Wurm.

James Merrill grew up in the San Francisco area in the '60's and has worked as a ranger, roofer, ski photographer, bike mechanic, as well as a film publicist while living in the Zen Center in L.A. Later, he attended the Jack Kerouac School of Disembodied Poetics, in Boulder, CO, where he translated poems by Mario Trejo, one of Argentina's most distinguished poets. He teaches Creative Writing at the University of Colorado in Denver, and his poetry has appeared in *Bombay Gin, Exit 0,* and *Colorado North Review.*

Elmo Mondragon grew up in Llano Quemado, a small village south of Taos,NM. His earliest ambition as a child was to become an artist, but during high school he decided to become a writer, and then during college and soon after, a poet. Despite having written and read publicly for sixteen years this is the first time he has published.

Mary Morris is a writer who is completing a book of poems called "One Who Deals Light," She lives in Santa Fe, NM with her son. She writes of deserts and rivers but dreams in tropical waters.

Joe Mowrey is a publisher and an editor who owns and operates Mariposa Printing & Publishing. He writes poetry, runs printing presses, and lives for his evening walks in the woods outside of Santa Fe, NM where he shares a home with his

spouse, their six cats, and three dogs. His work has appeared in various literary journals and anthologies. He insists that cat hair has mysterious healing properties.

Tim Myers is a writer, songwriter, and storyteller. He has published poetry, fiction and non-fiction for both children and adults. He currently writes and teaches writing at SUNY Plattsburgh, NY. A stay-at-home dad, his most recent book is *A Man's Guide to Being Home with Kids*.

Jim Nason was born in Montreal and received his M.A. in English Literature from McGill University. His publications include a book of poems : *If Lips Were As Red*. He has recently completed his first novel *Raining in the Memory House*, and is working on a new collection, *The Housekeeping Journals: Poems and Stories*.

Ann Newell has been a member of the Haiku Society of New York for 15 years. Her book *Moon Puddles* (reprinted by Durazno Design Publishing, 1996) was chosen by SUNY, Buffalo for their poetry rare books library, the State Library of California in Sacramento for their haiku archives, and by Brown University for their collection of rare books of poetry. She makes her home in Tularosa, NM. "evening" was published by Haiku Society of America *(frog pond 1982)*

John Oughton, a native of Guelph, Ontario, now lives in Toronto. He teaches courses on writing, computers, and technology at community colleges, and has written four books of poetry, including *Gearing of Love* and *Mata Hari's Lost Words*. "Growing Up a Block Away from John McCrae," "For Erin," and "William Tell's Son Speaks" appeared in his most recent book, *Counting Out the Millennium* (Pecan Grove Press).

Todd Palmer, born in Des Moines, IA, has lived in Florida for the past twenty-five years and graduated from the University of Florida in 1984. His poems have appeared in numerous publications, including *Ideals, English Journal,* and *Harp-Strings*. His first book of poetry, *Shadowless Flight*, won the 1997 Stevens Manuscript competition. He lives with his wife and three daughters in Port Orange, FL. "Fishing at Nightfall" will appear in *Shadowless Flight* (Lake Shore Publishing, 1997).

Alan Michael Parker is the author of *Days Like Prose* (Alef Books, 1997), co-editor of *The Routledge Anthology of Cross-Gendered Verse* (Routledge Books, 1996), and North American Editor for *Who's Who in 20th Century Poetry* (Routledge Books, 1999). His book reviews appear regularly in *The New Yorker*. He is an assistant professor of English at Penn State Erie, The Behrend College; he lives in Erie, PA with his wife, the painter Felicia Van Bork, and son, Eli. "Gents" originally appeared in *Grand Street* (Vol 8, No.4)

Binnie Pasquier has been published in various journals including *Poets On, Thema,* and *Xanadu*. She teaches English-as-a-Second Language and is a board member and the newsletter editor of the *Long Island Poetry Collective*.

Lee Patton has been published in *Threepenny Review, Massachusetts Review, Green Fuse* and *Men as We Are* and other journals and anthologies. His play, *The Houseguest*, won the Border Playwrights Prize; *Orwell in Orlando* was showcased in the 1996 Ashland New Plays Festival. He lives in Denver.

Roger Pfingston was born and raised in Evansville, IN, and for the past 31 years has taught English and photography in Bloomington. He is the recipient of a Creative Writing Fellowship from the National Endowment for the Arts and two PEN Syndicated Fiction Awards. "Brett's Game" appeared in *Yankee* (October 1992), and "Emmett's Decision" appeared in *Paragraph,* issue 7, 1990.

Karen Piconi is a freelance writer. In addition to publishing poetry, fiction and essays, she teaches writing at Iowa State University and conducts proposal and grant writing seminars all over the country. Her poetry, fiction, and essays have been published in *Common Journeys, Elephant Ear,* and *Kalliope: Journal of Women's Art.*

Kenneth Pobo has work appearing in *Cumberland Poetry Journal, Mudfish, Nimrod,* and *Outerbridge.* His most recent collection is *A Barbaric Yawp on the Rocks, Please* (Alpha Beat Press).

Judith Rafaela specializes in professions beginning with "P". She is a physician, parent, poet, and publisher. She co-edited *Written with a Spoon, a Poet's Cookbook* (Sherman Asher Publishing). "My Husband's Beard" and "Rio Pacuare" first appeared in *Poems Along the Path* (Sherman Asher Publishing, 1994).

Burt Rashbaum, a writer of fiction, non-fiction, and poetry for over twenty years, is a husband and father who lives at 8300 feet above sea-level in Colorado. He has an M.A. in Creative Writing, and is currently completing a novel.

Donald Rawley is the author of five books of poetry, a CD, a book of short stories, *Slow Dance on the Fault Line* (Harper Collins London, 1997), and a new novel, *The Nightbird Cantata* (Avon Books, Spring 1998). His short fiction, poetry, and essays appear regularly in *The New Yorker, Buzz, Yellow Silk, German Geo, Genre, Press,* and many other magazines worldwide. He has been nominated for both Pulitzer and Pushcart Prizes. "City of Men" first appeared in *Yellow Silk,* and in *Mecca* (Black Tie Press). "100 Miles from Nowhere" was first published in *Sirens* (The Quiet Lion Press).

Stella Reed resides near water just outside of Santa Fe, NM. She has been published in several anthologies and literary magazines nationwide, and is a 1996 Recursos Southwest Literary Center winner. Through the Whitney Project, a children's AIDS education program, she teaches poetry workshops in the schools.

Elisavietta Ritchie has published several collections, including *Tightening the Circle over Eel Country* (which won the Great Lakes Colleges 1975-76 Association's New Writer's Award), *Raking the Snow* (winner of the Washington Writers Publishing House 1981 competition), and the recent chapbooks *Wild Garlic: The Journal of Maria X* and *A Wound-Up Cat and Other Bedtime Stories.* Her poems have appeared in hundreds of publications, including *The New York Times, Negative Capability,* and *When I Am an Old Woman I Shall Wear Purple.* "Icarus, Manhattan" appeared in *The New York Quarterly,* and "The German Officer Inherits" in *Passager* and *Salmon.*

Charles Rossiter is 1/3 of the performance poetry group, 3 Guys from Albany, who are currently in the process of executing their grand plan of performing in all

of the Albanys in North America. He has been awarded an NEA Fellowhip(1997). His most recent collection is On Reading the 1,000-Year-Old Sorrows in a Book of Chinese Poems. "What Men Talk About" first appeared in "3 Guys from Albany" JiffyBoog Chapbook #3, 1995.

Michael E. Ryan writes from a small town in northwestern Wisconsin, where he also serves as a volunteer firefighter and EMT.

Miriam Sagan was born in Manhattan and holds a B.A. with honors from Harvard University and an M.A. in Creative Writing from Boston University. Her recent poetry titles include The Art of Love (La Alameda Press, 1994), Pocahontas Discovers America (Adastra, 1993), and True Body (Parallax Press, 1991). She is the editor, with Sharon Neiderman, of New Mexico Poetry Renaissance (Red Crane, 1994) and, with Robert Winson, Buddhist Poems of Philip Whalen (Parallax, 1996). Her novels are Coastal Lives (Center Press, 1991) and Black Rainbow (HiJinxs, 1997).

Trinidad Sánchez Jr. is a nationally known Chicano author of several books of poetry including the best seller Why Am I So Brown? (Abrazo Press, 1991). Pecan Grove Press of St. Mary's University, San Antonio is reprinting Father/Son Poetry. He is a producer of a weekly poetry series at The Twig Bookshop and the Jalapeño Blues Corner in San Antonio. Since 1995 he has taught in the San Antonio Independent School District, Artist in Education Program. He was a featured poet at the 1997 Albuquerque Poetry Festival.

Daniel Sargent is a senior at the Pennsylvania State University, the Behrend College, majoring in English/Creative Writing. He has recently finished his thesis entitled "Moving to the Core: Spiritual Pragmatism and the Writing of Vision," from which the poems "Dreaming of Montana" and "Sliabh, Loch, Agus Fear Ce Taraing Anail Iad" are taken.

Lawrence Schimel is the author or editor of more than twenty books, including Two Hearts Desire (St. Martins Press), Switch Hitters (Cleis Press), and The Drag Queen of Elfland (UltraViolet Library). His poems have appeared in numerous magazines and over a hundred anthologies, including Best Gay Erotic Writing of 1997 and the Random House Treasury of Light Verse.

Deloris Selinsky is a member of both the Wyoming Valley Poetry Society and the Pennsylvania Poetry Society. She has published three chapbooks of poetry. Deloris has a B.A. in Political Science and a M.A. in Human Resources Management.

Kaylock Sellers, born and raised in St. Louis, MO, has lived in Santa Fe, NM since 1981. He studied journalism and philosophy at the Lindenwood Colleges and the College of Santa Fe.

April Selley is a college professor and freelance writer of poetry, non-fiction, and fiction. She is currently a Fulbright Lecturer in American Literature at Tokyo Woman's Christian University.

Jim Simmerman lives in Flagstaff, AZ, where he is professor of English at Northern Arizona University. His most recent book of poems, Moon Go Away, I Don't

Love You No More (Miami University Press, 1994), was nominated for the Pulitzer Prize and National Book Award in 1994. He is also co-editor of *Dog Music: Poetry about Dogs* (St. Martin's Press, 1996), newly released in paperback. Individual poems have appeared in *Ploughshares, Antioch Review,* and *Bread Loaf Anthology of Contemporary American Poetry.* He won a Pushcart Prize for poetry in 1985.

Joan Jobe Smith, founding editor of *Pearl* magazine, has published 13 volumes of poetry, including *The Honeymoon of King Kong & Emily Dickinson* (Zerx Press, 1993) with her husband poet Fred Voss. Two of her books of poetry will be published in 1997: *The Pow Wow Cafe* (Poetry Business, England) and *Love Birds* (Chiron Press), a collaboration with Fred Voss.

Gerard Donnelley Smith is a professor of English at Clark College, Vancouver, WA. He is the founder of the Native American Center for Holocaust Studies as well as a performance artist, musician, and part-time sheepshearer. His first chapbook, *Hill of the Star,* was chosen as the Governor's Award for the Arts in Ohio, 1992.

J.D. Smith has recently published his poetry in *Visions International, The Ledge,* and *Mudfish* among other journals throughout the United States. He also writes children's books, fiction, and essays.

Michael S. Smith has a day job as a risk manager for an international agricultural cooperative; however, his real life is devoted to writing. He has over 200 publications in more than 100 literary journals and anthologies. He, his wife, and cat live in Bloomington, IL. "Day Timer" first appeared in *The Heartlight Journal.*

Thomas R. Smith is the assistant editor of Ally Press in St. Paul, MN and one of the founding editors of *Inroads* (a men's soulwork journal). His two books are *Keeping the Star* (New Rivers) and *Horse of Earth* (Holy Cow! Press). "Cattails," "The Muskie," and "The Masculine Art of Longing" first appeared in *Horse of Earth.*

Daniel Sogan is poet and Japanese Tea Master who studied and lived in Japan for ten years. He now makes his home in Santa Fe, NM. "bronzed boy" is from *The Realm of the Jade Scepter.*

Gary Soto is the author of twenty-five books of poetry, essays, a play, fiction, and children's literature, including *Living Up the Street, Jesse, Novio Boy,* and *New and Selected Poems.* He is working on a libretto, tentatively titled "Nerd-Landia" for the Los Angeles Opera's opera-in-the-school program. He divides his time between his hometown Fresno and Berkeley, CA.

Jeremy Spears is the recipient of the David Lindahl Memorial Prize for Poetry from the *James White Review.* His poems have appeared in such publications as the *Plum Review, Green Mountain Review, Illinois Review, James White Review,* and others.

Donna Spector is a writer whose poems, stories, and monologues have appeared in *Gaia, The Bellingham Review, Poet & Critic, In the West of Ireland,* and other journals and anthologies. Her plays have been produced Off-Broadway, regionally, and in Canada. "My Father's Breakfast" was published in *Sycamore Review.* "For Women Who Wonder at the Misanthropy of Certain Men" was published in *Blue Unicorn.*

Hans Jorg Stahlschmidt is a German writer who moved to Berkeley, CA 14 years ago. He works as a building contractor and is completing his Ph.D. in clinical psychology. His poetry has appeared in *Madison Review, Texas Poetry Review,* and *Coracle* among others. "German Childhood" appeared in *Beneath the Surface,* Spring 1995, Canada; "Meeting the Buddha near Bangalore", *Atlanta Review,* Summer 1996, and "Cranes Mate for Life", *Cumberland Poetry Review,* Fall 1995.

Ruth Stone was born in 1915 in Roanoke, Virginia. Her numerous honors include the Bunting Fellowship, two Guggenheim Fellowships, the Delmore Schwartz Award, and the Shelley Memorial Award. She is Professor of English at the State University of New York, Binghamton and lives in Vermont. "The Sperm and the Egg" appeared in *Simplicity* (Paris Press 1995).

Lisa C. Taylor makes her home in northeastern Connecticut where she often ponders the male experience while writing poetry, fiction, and nonfiction. She is currently finishing a new poetry collection *Measuring the Moon* and a writing book for kids based on a program she piloted in public schools. In her free time, she works as a psychotherapist in an alternative high school, travels, and enjoys her family. "The Man" first appeared in the collection *Safe Love and Other Political Acts* (Plumeria Press, 1995).

Mark Thoma is currently working towards an M.F.A. degree (creative writing) at the University of Missouri-St. Louis. Most recently his short fiction appeared in *Echoes,* and his poetry is forthcoming in the anthology *Frida on My Mind.* A native of St. Louis, he makes his living as a social worker in home health care.

Madeline Tiger teaches in the New Jersey State Council on the Arts WITS program and in the Dodge Foundation poetry programs. Her recent collections of poetry are *Water Has No Color, Mary of Migdal,* and *My Father's Harmonica.* For over thirty years she has lived in Montclair, NJ, where she raised four sons and a daughter. She learned something about gender. Now she travels often to visit her children and her four grandsons. She is learning about love. "This Man" appears in the *Patterson Literary Review,* 1997.

Frank Van Zant is a teacher of near-dropouts, coach, and father of three. He has won awards from GWU, CW Post, TDM Press, a CBE fellowship for a poetry research project, and a 1995 Pushcart nomination. Recent work appears in or is accepted by *Context South, Yankee, Negative Capability,* and *Poet Lore.* He has been anthologized in *What's Become of Eden* (Slapering Hol Press) and *Our Mothers, Our Selves.*

Fred Voss was recently featured for the third time in *The Wormwood Review,* and did his second whistle stop reading tour in England to promote *Goodstone* published in Britain by Bloodaxe Books and in the U.S. by Event Horizon Press. A second collection with his wife, Joan Jobe Smith, is due soon as is a pamphlet from Penniless Press in England.

Burton D. Wasserman was born and raised in New York City. He has been employed as a teacher, a real estate manger, and a comedy writer. His poetry has most

recently appeared in *Atlanta Review, Black River Review, California Quarterly,* and *Fox Cry.* "Sweating It" and "Sons" were published in *Hand-Mining the Cosmos* (Golden Quill Press, 1991).

Daniel Williams has written about the western slope of the Sierra Nevada in California for 25 years. His life's work is found in five collections of Sierra poetry: *Brief History of Motherlode, Shaman Dreams Dark Houses, Cold Ceremonial, riverrun,* and *Lost Diary of John B. Lembert.*

Christopher Woods is a Texas native who writes poetry, plays, fiction, and non-fiction. He is the author of a novel, *The Dream Patch.* His plays have been produced in Houston, Los Angeles, Chicago, and New York City. "Claiming Kin" appeared previously in *i.e. magazine.*

Joanne Young, born in New York City, is an emerging poet living in Santa Fe, NM where she has lived since 1980. First published in *Catch Our Breath: Writing from the Heart of AIDS* (Mariposa Printing & Publishing, 1996), she was also a finalist in the Taos Poetry Circus Open Mike Slam, and 1996 winner in the Recursos Discovery competition. Joanne says she remains in Santa Fe not for the poetic inspiration of the landscape but because, like the climate, the men there are hotter.

INDEX

About The Press

Sherman Asher Publishing, an independent press established in 1994, is dedicated to changing the world one book at a time. We are committed to the power of truth and the craft of language expressed by publishing fine poetry, books on writing, and other books we love. You can play a role. Bring the gift of poetry into your life and the lives of others. Attend readings, teach classes, support your local bookstore, and buy poetry.

Colophon:
Set in Adobe ITC Berkeley
File sections in Vintage Typewriter, Device, and Orator
Clip Art is Art Parts
Printed on Couger Natural
Cover stock is French Speckletone, 70% recycled.
Printed in the United States by Marrakech Express

Poetry and Books on Writing
Sherman Asher Publishing

Written with a Spoon, A Poet's Cookbook, edited by Fay and Rafaela
ISBN 0-9644196-2-9 Paper, 200 pages, $18.00
An eclectic collection of food and verse, original poems gathered from poets nationwide are combined with favorite and heirloom recipes to create a melting pot of unique flavors. Over seventy recipes are paired with related poems weaving into the ingredient list a touch of romance and a spoonful of laughter.

A Presence of Angels, Judyth Hill ISBN 0-9644196-1-0 Paper 72 pages, $12.00
Collected poems filled with the craft and passion of writing and the luminous presence of muses and angels, from Cezanne and Duchamp, to the dark angels of mothers and lovers.

Men Need Space, Judyth Hill ISBN 0-9644196-3-7 Paper, 72 pages, $12.00
These poems, arranged as a tribute to growth in relationships and writing, move through expectation, disillusion, and disintegration, to seeing and loving people as they really are and love in its deepest sense. Sure to please anyone in a relationship.

Movies in the Mind: How to Build a Short Story, Colleen Mariah Rae
ISBN 0-9644196-5-3 Paper, 142 pages, $14.95
A Writer's Digest Book Club Selection, *Movies in the Mind* brings Rae's celebrated workshops to the page. A **must** for every writer of fiction from novice to novelist. Contains inspiring exercises and an extensive bibliography.

Listening For Cactus, Mary McGinnis ISBN 0-9644196-4-5 Paper, 96 pages, $14.00 Also available on Audio Cassette, $5.95
These poems are celebrations of the seen and unseen, the New Mexico landscape, its colors, and silences. Blind since birth, she has written with power and humor about the disability experience, wild pears, and the dreams she doesn't remember. "I have been listening to the poems of Mary McGinnis for many years. They continue to move me to listen." Joy Harjo, poet and musician.

Poems Along the Path, Judith Rafaela ISBN 0-9644196-0-2, 48 pages, $10.00
In this acclaimed collection spanning twenty years, from an Oklahoma childhood to Kathmandu cafes, Rafaela writes as physician, wife, traveler and passionate Jew.

Available at fine book stores or directly from the publisher
1-888-984-2686